24. JUN 1991

Art in Context

27. JUL. 1995

...ie Ghent Altarpiece

6654

00002978

ENTERED

Art in Context

Edited by John Fleming and Hugh Honour

Each volume in this series discusses a famous painting or sculpture as both image and idea in its context – whether stylistic, technical, literary, psychological, religious, social or political. In what circumstances was it conceived and created? What did the artist hope to achieve? What means did he employ, subconscious or conscious? Did he succeed? Or how far did he succeed? His preparatory drawings and sketches often allow us some insight into the creative process and other artists' renderings of the same or similar themes help us to understand his problems and ambitions. Technique and his handling of the medium are fascinating to watch close up. And the work's impact on contemporaries and its later influence on other artists can illuminate its meaning for us today.

By focusing on these outstanding paintings and sculptures our understanding of the artist and the world in which he lived is sharpened. But since all great works of art are unique and every one presents individual problems of understanding and appreciation, the authors of these volumes emphasize whichever aspects seem most relevant. And many great masterpieces, too often and too easily accepted and dismissed because they have become familiar, are shown to contain further and deeper layers of meaning for us.

Art in Context

Hubert and Jan van Eyck probably came from Maaseik. Very little is known about Hubert except his death on 18 September 1426 and burial in St Bavo's Cathedral, Ghent. Apart from the Ghent Altarpiece, no works by him have as yet been certainly identified. Much more is known about Jan van Eyck who was prominent both as a painter and as a courtier and diplomat. He was in the service of John of Bavaria, Count of Holland, from 1422 to 1424 and later became court painter and varlet de chambre *to Philip the Good, Duke of Burgundy, for whom he went to Portugal and Spain in 1428–9. After Philip's marriage to Isabella of Portugal in 1430, Jan van Eyck settled in Bruges and married. He died on 9 July 1441. Several signed and dated paintings by him survive. He and his brother Hubert were for long credited with the invention of oil painting and although this may not be tenable Jan van Eyck certainly brought the new medium of oil and varnish to a high degree of accomplishment. He was the greatest artist of the Early Netherlandish School.*

The Ghent Altarpiece is painted in oil on twelve panels of oak and measures 375 x 517 cm. when open. The central panel The Adoration of the Lamb *measures 134.3 x 237.5 cm. The Altarpiece was finished by 1432 when it was installed in the Vijd chapel in St Bavo's Cathedral in Ghent, where it still remains. Several panels were dispersed in the nineteenth century but were reunited in 1920 and the altarpiece is now intact, except for the predella (lost before 1550) and one panel which was stolen in 1934 and is replaced by a copy.*

Allen Lane

Van Eyck: The Ghent Altarpiece

Elisabeth Dhanens

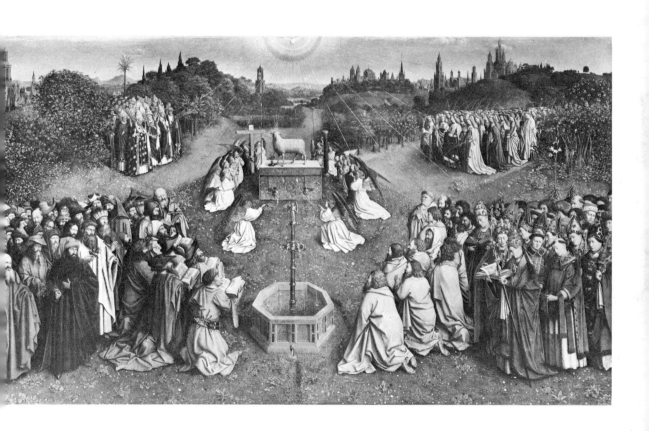

Copyright © Elisabeth Dhanens, 1973
First published in 1973

Allen Lane
A Division of Penguin Books Ltd
21 John Street, London WC1N 2BT

ISBN 07139 0407 0
Filmset in Monophoto Ehrhardt by Oliver Burridge Filmsetting Ltd, Crawley, England
Colour plate reproduced and printed by Colour Reproductions Ltd, Billericay, England
Printed and bound by W. & J. Mackay Ltd, Chatham, England
Designed by Gerald Cinamon

Reference colour plate at end of book

Acknowledgements

My warm thanks are due to J. de Baets O.P. for kind help with the translation of some of the Latin texts cited, to Dr K. Fremantle for the idea that a work by Donatello may have inspired one of the features of the Altarpiece and for suggestions concerning the arrangement of the text, and to Hugh Honour who pointed out that the landscape in the lower panels of the open Altarpiece is in part ultimately derived from the *locus amoenus* or ideal landscape of classical literature. I am also deeply indebted to those who, with great care and devotion, prepared the English version in which the text appears. For the use of photographs of the Ghent Altarpiece thanks are due to L. Haemers, who specially made the colour photograph used for the cover, to the Royal Institute for Art Patrimony, Brussels, and to the National Centre for the Study of Flemish Primitives. Finally, to John Fleming my thanks for his editorial help at all times.

Eeklo, December 1971

Historical Table

1414–18	Council of Constance.
1415	John Huss burnt as a heretic. Henry V defeats French at Agincourt.
1416	
1417	Pope Martin V elected.
1418	Pope condemns doctrines of Wycliffe and Huss: end of Western Schism.
1419	Jean sans Peur murdered, succeeded by Philip the Good.
1420	Henry V marries Catherine of France: enters Paris.
1422–4	
1422	Henry V dies.
1424	
1425	Joos Vijd in Philip the Good's suite.
1426	
1426–8	
1428	Philip the Good acquires Holland, Zeeland and Hainault.
1429	Joan of Arc raises the siege of Orleans.
1430	Philip the Good marries Isabella of Portugal and creates Order of the Golden Fleece.
1431–49	Council of Basle.
1431	Joan of Arc burnt at Rouen. Pope Eugene IV elected.
1432	
1433	
1434	
1435	Legal registration of the Vijd–Borluut foundation in Ghent. Peace of Arras between Philip the Good and Charles VII.
1436	French recover Paris.
1437	
1438	
1439	Joos Vijd dies.
1441	
1443	Elisabeth Borluut dies.
1444	

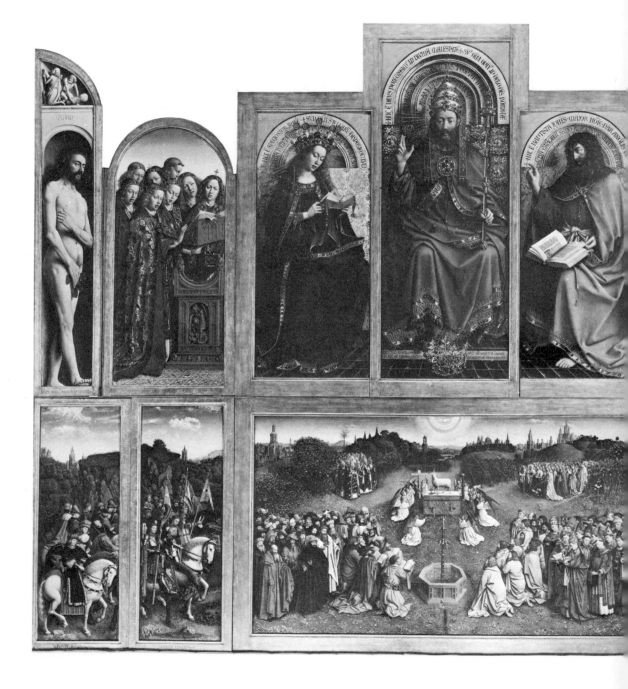

Introduction

Ever since its completion in 1432 the Ghent Altarpiece [1, 2 and colour plate pull-out at end of book], the splendid polyptych painted by the brothers Hubert and Jan van Eyck for a chantry in what is now St Bavo's Cathedral in Ghent, has fired the imagination of those who have seen it. It inspired many artists to emulation, above all in the fifteenth and sixteenth centuries, and many travellers recorded their impressions of it. Among these was Albrecht Dürer, who, during his journey in the Netherlands of 1521, noted in his diary: 'It is a most precious painting, full of thought (*ein über kostlich hoch verständig gemähl*), and the Eve, Mary and God the Father are specially good.'[1] Two and a half centuries later Sir Joshua Reynolds, visiting the Low Countries in his turn, reported that though the figures in the Altarpiece were painted in a hard manner, 'there is great character of *truth and nature* in the heads, and the *landscape* is well coloured'.[2] His remarks herald a new appreciation of the Altarpiece, for its style did not accord with eighteenth-century taste; in his day it was more often valued as the document of a turning-point in the development of painting rather than for its artistic merits. This was due in part to its reputation as one of the first paintings to be carried out in oil:[3] a claim which may be doubted, if only on the ground that much experimentation must have preceded the creation of a work of this kind, in which the new technique had evidently

1. The Ghent Altarpiece, open: completed 1432. Hubert and Jan van Eyck. Lower register panels: *The Just Judges, The Knights of Christ, The Adoration of the Lamb, The Holy Hermits, The Holy Pilgrims.* Upper register panels: *Adam* with *Cain and Abel* above, *The Singers, The Virgin Enthroned, Christ Enthroned, St John the Baptist Enthroned, The Musicians, Eve* with *Cain and Abel* above

been mastered. The use of oil paint clearly did not hamper the Van Eycks in painting the Altarpiece and it has stood up remarkably well to various adversities, among them incompetent cleaning, damage by fire, and being dismantled and moved a number of times. Large panel paintings such as those of which the Altarpiece is composed are particularly liable to suffer from the changes of temperature and humidity which moving used to involve. When the panels were hoisted for safety into the cathedral's tower to preserve them from sixteenth-century iconoclasts, and when wars struck the Southern Netherlands later, there were greater hazards, yet the Altar has survived them all. Apart from the predella, which was lost before 1550, its paintings, though separated for many years, remained complete in number until our own century; a panel stolen in 1934 has not been recovered and is now replaced by a replica.

Nineteen out of the twenty-one paintings which originally constituted the Ghent Altarpiece have survived virtually intact [1, 2]. Unlike most of the outstanding Netherlandish altarpieces of the fifteenth century now known, it may be seen today in the place for which it was designed. This is important, for only in this setting does the new degree of tangible realism (derived from early renaissance Italian art, whether at first or second hand) with which, as it appears, Jan van Eyck completed his more conservative brother's work, have its full effect. The frames of the panels in which the Annunciation is shown on the closed wings of the Altarpiece, lit by the windows of the chapel itself, seem to cast shadows on the floor of the Virgin's room; the majestic single figures of the upper part of the open Altarpiece, as though they too were lit by the windows of the church, cast shadows on the golden backgrounds, or the niches, behind them. These and other features which, as it were, bring the spectator in the Vijd chapel into direct contact with what is represented, lead one to wonder what the impact of other paintings by the Van Eycks, in their turn, would have been on those who saw them in their original setting. In this case we are more fully aware than usual of the nature of their achievements.

2. The Ghent Altarpiece, closed:
completed 1432. Hubert and
Jan van Eyck. Lower register panels:
*Joos Vijd, St John the Baptist, St
John the Evangelist, Elisabeth Borluut.*
Upper register panels· *The
Archangel Gabriel* with the *Prophet
Zechariah* above; interior with
the *Erythraean Sibyl* above; interior
with the *Cumaean Sibyl* above,
The Virgin Annunciate
with the *Prophet Micah* above

If the Ghent Altarpiece confronts us with an important moment in the history of art in a particularly forceful way, it is also closely linked with the environment in Ghent which gave rise to it and with the people concerned, in particular Joos Vijd, who founded the memorial chapel and commissioned the Altarpiece itself, the still unidentified scholar who devised the symbolic programme, and the artists themselves: Hubert van Eyck, highly honoured in his day but now relatively unknown, who designed the general scheme of the polyptych and must have executed the greater part of many of its panels, including the Adoration of the Lamb itself, and the younger Jan, of whom much more is known because he was a courtier, and because signed works by him have survived. The Altarpiece moreover reflects theological ideas in circulation at the time. The paintings of which it is composed express the whole complex, abstract, dogmatic theme of the Redemption of Man in remarkably concrete terms (matched at many points by the concrete realism of the Van Eycks) and with striking unity. The iconographic scheme of the Altarpiece and the concrete imagery with which its ideas are expressed are foreshadowed in the commentaries of the twelfth-century theologian Rupert of Deutz. We know that these were in demand in northern Europe in the fifteenth century and it seems clear that they, in addition to many of the scriptural passages on which his writings were based, inspired important features of the Altar's symbolic programme.

Research into the origins and history of the Ghent Altarpiece began, as far as is known, in the mid sixteenth century. The literature devoted to it since that time, which reflects the changing tastes and methods of successive generations, would fill a small library. For reasons of space the many debatable and, in my view, erroneous theories that have arisen through the years cannot be fully discussed in the present volume, though some are mentioned in passing, and in spite of the author's indebtedness to many earlier writers, no exhaustive list of literature on the Ghent Altarpiece can be given. A short bibliography is, however, included (p. 143 below), in which

references are given to surveys of the literature of different periods, to standard works on various aspects of the subject, and to some recent publications on the Altarpiece's symbolism.

To add yet another item to so large a body of literature is perhaps presumptuous. Yet it seems that a revaluation of certain aspects of the Ghent Altarpiece is due. The purpose of the present volume is to give a short survey of what is now known or can be deduced with reasonable certainty about the Ghent Altarpiece, coupling this with a reassessment of the shares in it of Hubert and Jan van Eyck, and including the results of new research into both the early documents concerning the Altarpiece and its donors, and the environment which gave rise to it, to which, as time passes, it is ever more necessary to return. In addition, the writings of Rupert of Deutz are discussed for the first time in relation to the Ghent Altarpiece, though of necessity only briefly and a new though tentative reconstruction of the original arrangement of the Altarpiece is presented, based on archaeological evidence and geometrical principles.

For the sake of clarity inscriptions appearing on the Ghent Altarpiece are quoted in capitals in the text which follows, whatever the original form of the lettering; in most cases both contractions and abbreviations are expanded silently, the letter U is substituted for the older form V, and punctuation is occasionally supplied. The exact original form of the inscriptions may be found in the publication of J. Duverger (1945) and of J. de Baets O.P., mentioned in the bibliography.

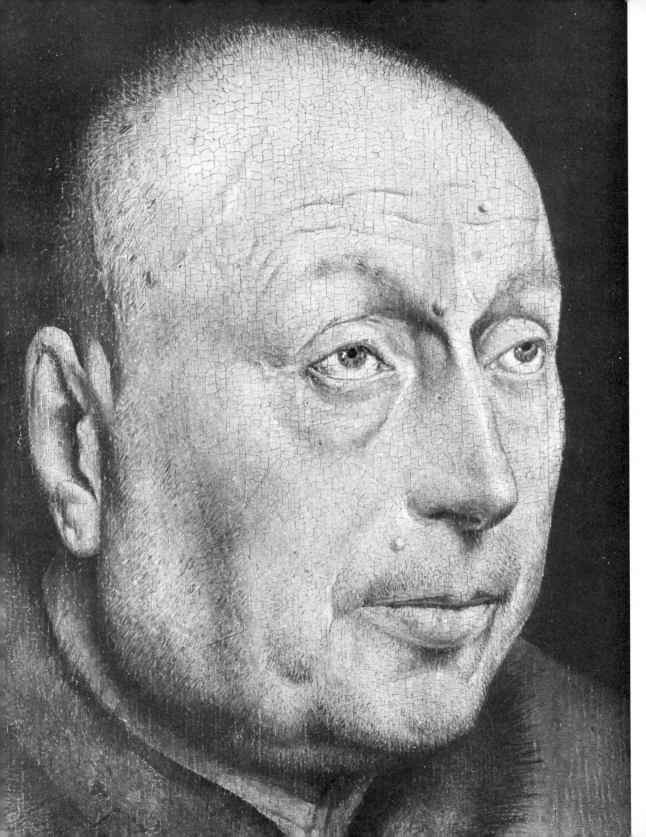

1. The Setting

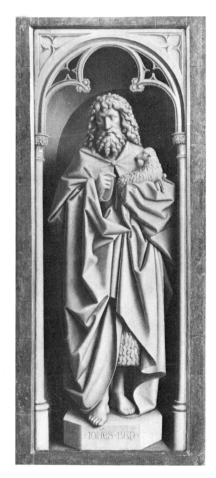

The city of Ghent grew up at the confluence of the Scheldt and the Lys, near the Castle of the Counts of Flanders and between two abbeys, St Bavo's and St Peter's, which prided themselves on having been founded by St Amand. It reached its economic and political zenith in the eleventh and twelfth centuries. Later it suffered from warring factions and social upheavals which gave it a turbulent and bloody history, yet it continued to be a centre where creative thought and art flourished.

Ghent's patron saint was John the Baptist [4]. The connection between his attribute, the Lamb of God, and the wool industry which was one of the main sources of the city's prosperity is clear. St John appears on the earliest known seal of the city (1199), and the Lamb of God, the *Agnus Dei*, on the earliest known counter-seal (1244). A later medieval city seal of Ghent shows the saint carrying the Lamb, flanked by angels swinging censers. The city's oldest parish church, which was under the patronage of St Peter's Abbey, was originally dedicated to St John, and it was round this church, now St Bavo's Cathedral, that the powerful patricians of Ghent built their fortified stone houses (*steenen*). The Schepenhuis, or town hall, stood close by and the city's aldermen often served at St John's as churchwardens. Among those who did so was Joos Vijd [3], the founder of the chapel whose altar is adorned with the Van Eycks' polyptych, the Adoration of the Lamb.

The parish of St John had a long tradition of private patronage, for the earliest known benefactor of the church was a certain Lausus who made a pilgrimage to Jerusalem with his friend St Poppo (d. 1048). The crypt was associated with the Holy Sepulchre from early times. The church itself was almost certainly the meeting-place of pilgrims who had been to the Holy Land, just as St Nicholas's

3 (*opposite*). Slightly enlarged detail of the *Joos Vijd* panel

4 (*above*). The *St John the Baptist* panel

Church, Ghent, was for those who had been to Rome, and St James's for those who had visited Compostella. These connections with St John the Baptist and with Jerusalem help to explain parts of the Altarpiece's iconography. Some aspects of the church's history and of the environment in which the Altar came into being also have a bearing on its meaning.[4]

Throughout the long schism in the Western Church Ghent remained firmly on the side of Rome. In 1378, for example, Count Louis de Male summoned the clergy of Flanders to Ghent to examine the problem of obedience to Pope Urban VI, and even went so far as to send four abbots and two doctors of law to Rome to inquire into the legality of Urban's election. On their return the clergy affirmed their allegiance to him. It seems that the civic authorities fostered this loyalty, for in a bull dated 18 March 1432, shortly after Cardinal Albergati had visited the city as an emissary of Martin V, the Pope acknowledged Ghent's constant allegiance to the Church in Rome by granting the city the right to use red wax for its official seal.

Among the three parish priests of St John's there was almost always one of some academic standing. When the Adoration of the Lamb was painted there were two such priests: Master Johannes van Impe (c. 1421–40) and Master Arnoldus Roebosch (c. 1421–31), who was at the same time canon of the church of the castle, St Veerle's, and thus may perhaps have been a non-resident priest.[5] Ghent scholars had usually attended the University of Paris up to this time, but now every effort was being made at the recently founded University of Louvain to establish contact with Ghent. Roebosch was enrolled at Louvain in or about 1427 and Van Impe was enrolled there about 1432. The exact nature of their enrolment is not known, for both had served at St John's since 1421. Evidently Van Impe cared deeply for the house of God in which he served, for in his day its ambulatory, its five radial chapels and its sacristy were completed. The city authorities made a special grant towards these projects in the financial year 1430–31 and Joos Vijd, the donor

of the Adoration of the Lamb, who was an alderman at the time, undertook to pay for one of the chapels himself.

When Van Impe was buried in the crypt of his church, in the place of honour under the high altar, his services to the parish during more than twenty years were commemorated in a rhymed epitaph on his gravestone. Among his deeds was the foundation near St John's, probably in 1429, of the House of St Jerome: 'after the pattern of the foundations at Deventer and Zwolle, in order that devout priests might live there in the way in which the Apostles had lived.' In spite of this reference to the foundations of the Brotherhood of the Common Life, where the Devotio Moderna, which had been inspired by Geert Groote, was practised, Van Impe does not seem to have been a member of the Brotherhood himself. We must therefore beware of connecting him with it too closely. Yet he must have been acquainted with its members' ideals and way of life and must have shared their dedication to the scriptorium. He was knowledgeable in this field, for it is recorded that he inspected the scribes' work at the Ghent foundation. No fewer than eighteen books are represented on the Ghent Altarpiece [5]. This cannot

5. Detail of the *St John the Baptist Enthroned* panel

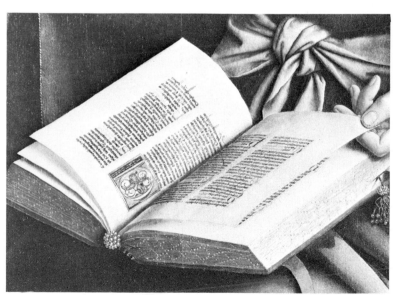

have been due to chance. The Altarpiece came into being at a time when the Apostolic period of the Church's history was held in great reverence, in an atmosphere of Christian humanism, of devout erudition, and of concern for the Church's didactic task. This helps to explain its dogmatic character.

The church of St John lost its original name when, in 1540, Charles V handed it over to the Chapter of St Bavo's Abbey as part of the process by which the city of Ghent was stripped of its liberties and privileges after its revolt against him. Shortly after 1559 the church, now dedicated to St Bavo, was raised to the status of cathedral and since that time, through the munificence of its bishops and canons, it has become exceptionally rich in works of art. The greater part of the building and its oldest treasures, among which the Adoration of the Lamb takes pride of place, were nevertheless the creation of the parish community.

THE VIJD FOUNDATION

Joos Vijd and his wife Elisabeth Borluut founded the westernmost radial chapel on the south side of the raised area at the east end of the choir of St John's Church [6A, B]. The material extent of their foundation is marked by the arms of Vijd and Vijd–Borluut carved on the keystones of the vaulting of the chapel itself and of the adjacent bay of the ambulatory. At first the chapel was referred to as that of Joos Vijd, but after the church was transferred to the

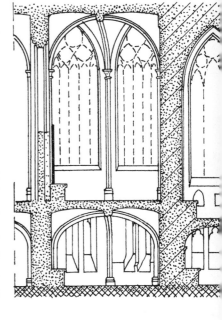

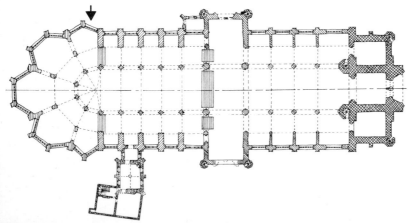

6A (*above*). Section of the Vijd Chapel, St Bavo's Cathedral, Ghent

6B (*left*). Plan of the cathedral showing location of the Vijd Chapel

7A, B (*opposite*). The *Joos Vijd* and *Elisabeth Borluut* panels

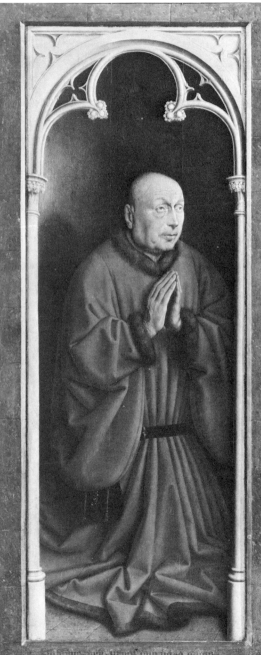
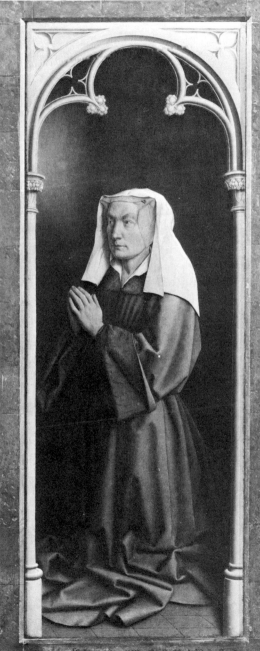

Chapter of St Bavo's Abbey, when many traditions died out, it came to be known as the chapel of Adam and Eve owing to the fame of these figures in the altarpiece.

The chapel was founded for the celebration of a daily mass whose institution was registered by the city authorities in a deed dated 13 May 1435.[6] This deed records that Joos Vijd, Lord of Pamele and Ledeberg, and Elisabeth Borluut his wife [7A, B], 'do, to the glory of God, His Blessed Mother and all His saints, establish in perpetuity the office of a daily mass for the salvation of their souls and those of their forebears, in the chapel and at the altar that they have caused to be erected at their own cost on the south side of the church'. The deed specifies in detail the measures that are to be taken in connection with the endowment and establishment of the chaplaincy, the conduct of services at the altar, and the perpetuity of the foundation, all possible precautions being taken to ensure the preservation and inalienability of the chapel's ornaments. Though the document is couched in legal language it cannot conceal Joos Vijd's determination to leave nothing to chance.

The deed makes no specific mention of the altar's including a work of art. It simply states that the mass will be celebrated 'in the chapel and at the altar' that Vijd and his wife 'have caused to be newly made'. The word altar, however, very often combined the meaning of altar in the strict sense, and retable with its paintings, sculptures, and other ornaments.

The Adoration of the Lamb was indeed an integral part of the altar of the Vijd Chapel, at which mass was to be said daily for the souls of the donors and their ancestors. An altar is depicted in the Van Eycks' polyptych itself [8]: one bearing the Lamb of God, the symbol of Christ, just as the real altar in the chapel bore the Body and Blood of Christ in the Sacrament. The inner relationships between the altar itself and the Altarpiece, and those between the terms of the foundation and the purpose and function of the altar and Altarpiece combined, are reflected in the iconography of the work.

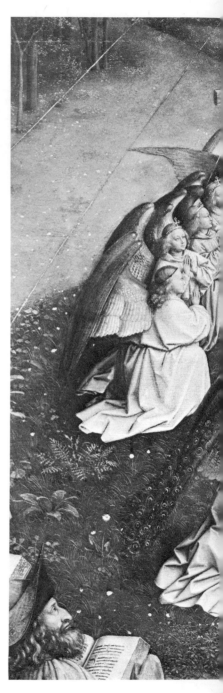

8. Detail of *The Adoration of the Lamb* panel

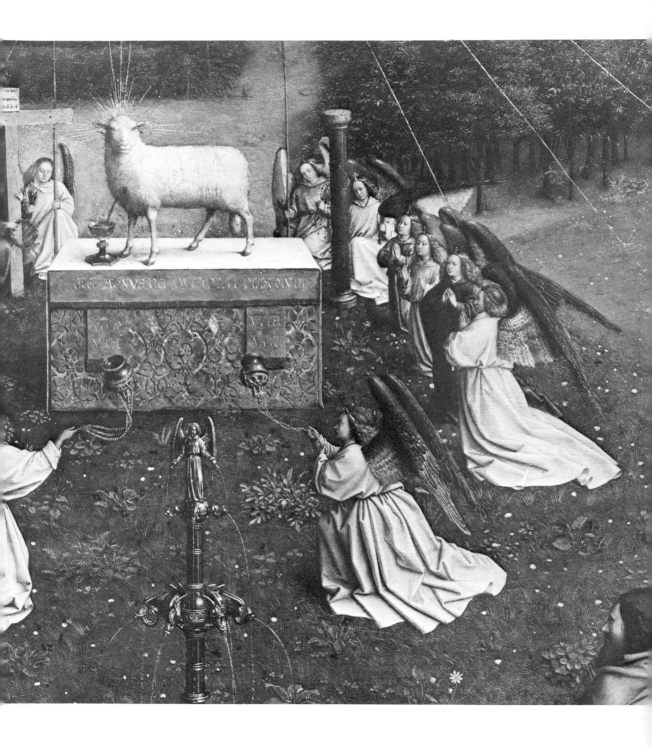

2. The Dedicatory Inscription

Our only direct contemporary source of information about the Altarpiece's origin, artists, donor and date is a quatrain, painted on the frames, at the foot of the lower panels of the closed polyptych [9]: those in which the donors are portrayed with the saints to whom they pray. The quatrain reads:

PICTOR HUBERTUS EEYCK. MAIOR QUO NEMO REPERTUS
INCEPIT. PONDUS. QUE JOHANNES ARTE SECUNDUS
[FRATER] PERFECIT. JUDOCI VIJD PRECE FRETUS
VERSU SEXTA MAI. VOS COLLOCAT ACTA TUERI [1432]

These much discussed lines may be translated:

'The painter, Hubert van Eyck, than whom none was greater, began [this work], and his brother Jan, second in art, completed the

9. The Dedicatory Inscription

weighty task, at the request of Joos Vijd. On the sixth of May he [Vijd] begs you by means of this verse to take care of [i.e. on 6th May he places in your charge] what came into being.'

In the last line the date 1432 appears in a chronogram formed by letters painted in red (here printed in large capitals).

At some unknown time this inscription was painted over. It came to light only in 1823 when the frames of the outside panels were cleaned in the Kaiser Friedrich Museum, Berlin. By then there was already renewed interest in the quatrain in Ghent itself, where research on the Altarpiece had been stimulated by the out-cry that followed the sale of six of the side panels in 1816. Various early transcripts were already known. L. de Bast published one of these in 1823.[7] In the following year he published it again, together with a transcript made by G. F. Waagen, of the Berlin museum.[8] Waagen may have been in touch with the Ghent scholars and it is not impossible that the panels were cleaned in response to a request from Ghent.

The quatrain is hard to read, the more so since the first word of the third line (added here from the early transcripts) has been obliterated by wear. The text has, moreover, been misinterpreted because it was assumed that Jan van Eyck composed it or addressed the reader in it, and its authenticity has been challenged on the grounds that the versification is not entirely correct. Yet in 1432 an inscription of this kind, whose composition would be far from easy, would not take the form of a flawless classical verse. The many attempts that have been made to 'correct' the text cannot be justified. In 1933 E. Renders went so far as to declare the quatrain a forgery,[9] mainly because no earlier transcript is known than that which appears (though its presence there is surprising) in a collection of epitaphs made in the late sixteenth or early seventeenth century. Yet the absence of earlier records does not in itself indicate that the inscription was a later addition. The argument that chronograms were not known before the second half of the fifteenth century is equally unfounded. There is, moreover, positive evidence which,

10A, B. The *Prophet Micah* panel, and detail (*opposite*)

taken together, makes it clear that the inscription dates from the time when the Altarpiece was completed.

Both palaeography and style suggest that the quatrain is genuine. The lettering is in keeping with that current in Flanders in the fifteenth century and stands comparison with that of Ghent epitaphs of the time, and of other inscriptions on the Ghent Altarpiece itself [10, 60]. The verse is Leonine; that is, it consists of dactylic hexameters with internal rhymes. The fact that neither rhyme nor rhythm are entirely regular would tend to confirm rather than deny the inscription's authenticity. A writer of 1432 would have been less well-equipped to produce flawless verse than a writer of the sixteenth or the seventeenth century, just as the Van Eycks were less well-equipped to render perspective correctly than sixteenth- or seventeenth-century painters. The quatrain is, moreover, related stylistically to other rhymed inscriptions of the period which survive in Ghent: to the principal inscriptions (which are more or less in rhyme) on the three central upper panels of the Altar itself, to Johannes van Impe's epitaph,[10] and even to Hubert van Eyck's epitaph, which is in Flemish.[11] These inscriptions reveal a similar feeling for timbre and alliteration, an effort to control rhyme and rhythm, and, above all, a terseness and directness of expression

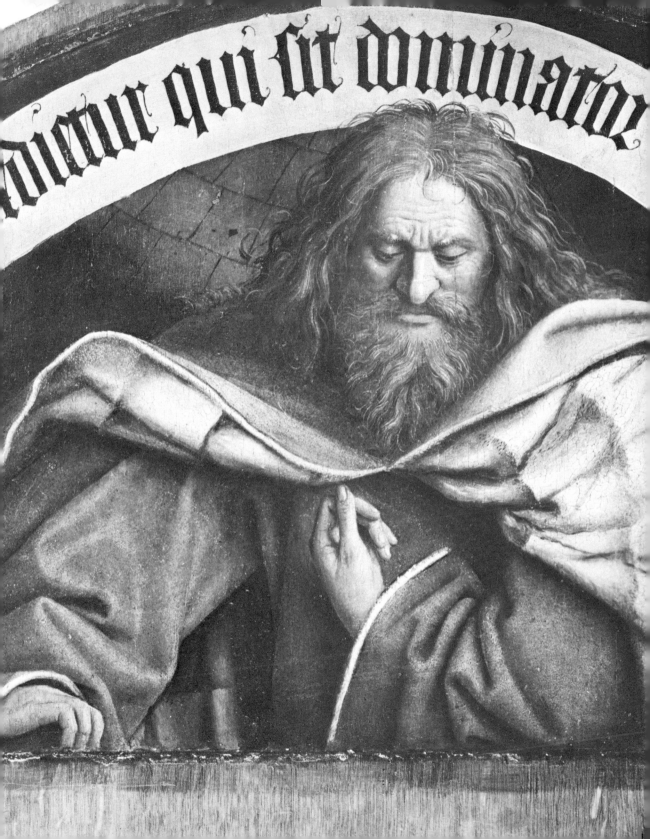

quite different from the style of the long-drawn-out doggerel produced by the late sixteenth-century Ghent chambers of rhetoric.

The quatrain's claim to authenticity is also supported by its psychological character. Its contents accord with the circumstances of the chapel's foundation and there can be little doubt that it was composed at Joos Vijd's request by some scholar of his acquaintance. It is a mannered verse commemorating a solemn occasion: one composed ingeniously and with deliberation. The restrictions imposed by the length of the lines, by the metre and rhymes and, in particular, by the chronogram, are all too evident, yet for the reader of 1432 the meaning was clear; the author could not be expected to foresee the different approach of twentieth-century scholars. Setting preconceived ideas aside we must try to understand the text by considering it in the context in which it was written.

The first concern of parish benefactors, whether the donors of modest gifts or of costly foundations or works of art, is the perpetuity and inalienability of their gift, and this concern is usually expressed by means of an inscription or coat of arms which may guarantee the preservation both of the gift and the memory of the donor. The Ghent Altarpiece, of which the dedicatory inscription forms an integral part, is, quite clearly, the lasting, concrete record of the foundation established by Joos Vijd and Elisabeth Borluut. The date, 6 May, must surely refer to the transfer of the work to the church authorities as well as to its completion. The Latin text of the quatrain embodies not an implied invitation to come and look at the polyptych, as many art-historians have supposed, but a request addressed to a small group of learned persons or, specifically, to the clergy of the parish of St John (who were charged with the upkeep of the church and the maintenance of its chantries), that the work, and indeed the foundation as a whole, should be carefully preserved. The importance of the Altar and of the artists who painted it is stressed, and the name of the donor is recorded, in the first place in order to encourage the clergy's sense of responsibility.

The inscription thus represents, in verse form, the contract between the donor and the recipients. Its essential significance is that of a conveyance, a solemn handing-over on condition that what is given shall be well looked after.

The supposed appraisal of the two artists, which has puzzled students of the Ghent Altarpiece ever since the sixteenth century, also becomes more intelligible when it is seen from the viewpoint of 1432. The quatrain does not imply any under-estimation of Jan. He was, after all, entrusted with the completion of the important task. In the circumstances of the time the words *arte secundus* (doubtless in part chosen to conform with the pattern of the verse) could only have meant that Jan was the younger artist: the second chronologically. The writer of the quatrain, believing unquestioning praise to be the dead Hubert's due, may have been expressing subjective admiration for him in words of commemoration charged with human affection. He was unaware of the important works that Jan was to create later (1434–9). Only in 1432 could the reference to the two artists have been framed in this way, for even one generation later the memory of Hubert had grown dim while Jan, because of his social status and his career as the confidential diplomatic agent of the Duke of Burgundy, had already acquired international fame. It seems that quite soon a need was felt, in referring to the altar, to amend the sentiments expressed in the quatrain. There may be a trace of this as early as 1517 in the travel notes of Antonio De Beatis, who wrote of the brother who finished the Altarpiece: *quale anche era gran pittore* ('who was also a great painter').

Some of those who believed that the inscription was a forgery have suggested that it was added to the Altarpiece in the late sixteenth or early seventeenth century to enhance Ghent's artistic importance in face of that of Bruges, a gesture which would have been unthinkable at the time. All the valid evidence points to the conclusion that the quatrain is an integral part of the Altarpiece. It is a historical document of the first order and a key to the work of art itself.

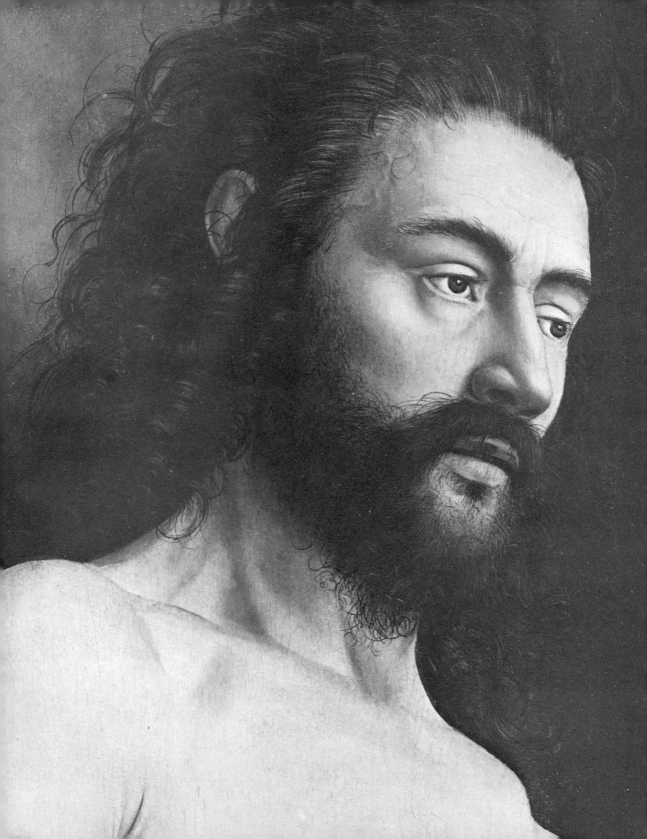

EARLY ACCOUNTS OF THE ALTARPIECE

The information given in the dedicatory verse is borne out in many particulars by secondary sources, for the most part found recently, the earliest of which are notes by foreign travellers who visited Ghent. In these travellers' notes echoes of the quatrain itself can be distinguished, as well as information which might well have come from an informant in the church. Too much store must not be set on such accounts, but they are important since they relate to the Altarpiece, in its setting, at first hand, and are independent of each other.

The earliest, and in view of this the most valuable, account of it is by Hieronymus Münzer, who in 1495 described it in some detail.[12] He does not, however, mention the outside panels, perhaps because he did not see the polyptych closed. Münzer is observant and, where his words can be verified, accurate, so can be trusted. He states that after the master had finished the work he received a payment of six hundred crowns above the sum originally agreed, and notes, after expressing profound admiration for the figures of Adam [11, 57, 70] and Eve [46, 57], that the master of the painting was buried in front of the altar of the Vijd chapel. Here Münzer must refer to Hubert's grave, for Jan was buried at Bruges.

A second traveller, Antonio de Beatis, recorded in 1517 that the 'canons' had told him that the work was carried out by a master from *la Magna Alta* whose name was Roberto, and that, since this master had not been able to finish the task 'because he had died' it was completed by his brother, who was also a great painter.[13] 'Roberto' may well be the name Hubert, misheard or mistranscribed, or may have been written in error. By *la Magna Alta* Germany (Allemagne) may be meant. The term must in any case refer to some area far to the east of Ghent. The details which De Beatis gives about the brother's completing the work correspond with the quatrain. His reference to the death of the first painter may be compared with Münzer's note about the master's grave.

The information given in the quatrain finds further corroboration in the writings of two sixteenth-century Ghent humanists, Lucas

11. Detail of the *Adam* panel

de Heere and Marcus van Vaernewyck. While Münzer and De Beatis recorded what they saw and heard on the spot, these later humanists combine eye-witness accounts with erudite knowledge and deliberate research. Their texts reflect the interest in history and topography which arose after St John's Church had been taken over by the Chapter of St Bavo's Abbey in 1540, an event which had caused much hostility and had resulted in a break in the parish's traditions. So serious was this break that in 1564 a memorandum was drawn up in order to record that 'with regard to the daily mass of Joos Vijd, who, it is believed, endowed many fine charities and foundations, it should be known how [this mass] was itself established'.[14]

Another stimulus for the renewed interest in the Altarpiece to which De Heere and Van Vaernewyck testify seems to have been the making by Michael Coxie in 1557 to 1559 of a copy (now dispersed) for Philip II of Spain.[15] De Heere, both a painter and a poet, undertook the writing of the lives of the Netherlandish painters in a lost work which was consulted by Carel van Mander. His surviving information about the Altar takes the form of an ode which he placed in the Vijd chapel when the twenty-third chapter of the Order of the Golden Fleece was held in St Bavo's in 1559.[16] Since he was concerned with the preparations for this chapter he may well have seen Coxie at work on his copy, which is mentioned in the ode. De Heere is primarily concerned with the artists, as was usual in the Renaissance; he appraises the Altarpiece without taking its function into account and does not mention the donors. It seems that he was the first to link local traditions concerning the Altarpiece with information about Jan van Eyck still current in court circles. Such information may have reached him through Viglius Aytta van Zuichem, Chancellor of the Order of the Golden Fleece and later Dean of the Chapter of St Bavo's. He mentions Giorgio Vasari, showing that he knew his account of Jan van Eyck in the first edition of his *Lives* (1550), in which, however, the Ghent Altarpiece is not referred to. Other parts of De Heere's ode derive from the quatrain

and from Hubert van Eyck's gravestone. There is no reason to question the truth of his information because it is incomplete and reaches us only in poetical form.

Marcus van Vaernewyck mentioned the Altar in both 1550 and 1562 in short rhymes about the sights of Ghent, but it is his accounts of the Altarpiece and its authors in two remarkable prose chronicles entitled, in translation, *The Mirror of Netherlandish Antiquity* (written *c.* 1561, revised 1565, published 1568) and *Of These Troubled Times* (written 1566–8, published 1872–81), which are of special importance.[17] In his *Layman's Philosophy* Van Vaernewyck had brought together further information about the Van Eyck family, but this work, unhappily, is lost. Like De Heere, Van Vaernewyck had read the first edition of Vasari; his accounts and De Heere's ode, though written independently, thus derive in part from a common source. Van Vaernewyck in his turn collected a considerable amount of information and, in particular, took the trouble to decipher Hubert van Eyck's epitaph, which was difficult to read even in his time. He tells how he 'spelled it out letter by letter', a task which was perhaps beyond the patience of the young Lucas de Heere. Yet Van Vaernewyck fails to name the donors, of whom he only records that they spent their money unsparingly on the work.

What other sources could these two writers have drawn on? Documents relating to the Altar may have been preserved in the House of St Jerome, which had a library as well as a busy scriptorium and a flourishing grammar school. The donors' successors, members of the Triest and Borluut families, would doubtless have been glad to provide information, for no families could have been prouder of a gift made by an earlier generation. They jealously watched over the Vijd chapel and its Altarpiece through the years and in the sixteenth century might well have known details passed down by oral tradition. The Willem Borluut of the day was, moreover, himself a humanist writer. De Heere had been tutor to a Joos Borluut, Lord of Sint-Denijs-Boekel. Van Vaernewyck, who came

from a leading family, might also have known informants such as these.

The greater part of the information given by De Heere and Van Vaernewyck is certainly trustworthy. They had no reason to distort the truth. Many particulars which they give are, indeed, confirmed by other authors, among them especially Luigi Guicciardini and Carel van Mander.[18]

3. The Donors and the Painters

Joos Vijd who, according to the third line of the quatrain, asked Jan van Eyck to complete the Ghent Altarpiece and who, with his wife Elisabeth Borluut, paid for the building of the chapel in which it stands, was the son of Nikolaas Vijd, knight, and Amelberga van der Elst.[19] His family, some of whose members had raised their status by military service, came from the area north of the Scheldt between Ghent and Antwerp known as the Land van Waas, and belonged to the lesser nobility. Nikolaas Vijd was appointed castellan of Beveren Waas in 1355. He remained in the service of his overlord, Louis de Male, the last of the counts of Flanders, for thirty-four years. With his two sons, Christoffel and Joos, he sided with Louis de Male during the revolt of Ghent of 1381. In 1385 he was bailiff and principal alderman of the Land van Waas and in 1387 bailiff of the Vier Ambachten. He was also lord of the manor of Pamele and Ledeberg. In 1390, after Philip the Bold, Duke of Burgundy, had succeeded the counts of Flanders (whose line had died out) as overlord, Vijd was found guilty of embezzlement by the newly-appointed controller of accounts. For this he was required to pay a large fine and was stripped of his offices. He settled in Ghent at this time. Whether the punishment was justified or was merely an excuse to be rid of him cannot be determined; it must in any case be seen against the background of the political and administrative changes of the time. Nikolaas Vijd lived on until 1412. He was buried at the Carthusian monastery of Rooigem near Ghent, where his body was given a place of honour because he had been a 'special benefactor' there.

It is not known how Vijd's children took their father's disgrace, which does not seem to have affected their careers directly. As well as the expression of a firm faith in the ultimate judgement of God,

an element of expiation may perhaps be detected in the gift of the Vijd chantry and of the Altarpiece itself. One is reminded of Enrico Scrovegni. Strong evidence suggests that Scrovegni founded the Arena Chapel in Padua, with its frescoes by Giotto, as an act of expiation on behalf of his father Rinaldo, who appears in Dante's *Inferno* (xvii, 64) condemned for usury. Joos Vijd too may have been inspired by a pious sense of filial duty to wipe out the memory of his father's humiliation by instituting a religious foundation, and by commissioning an exceptionally magnificent work of art. Seen in this light the Altarpiece, with its dogmatic representation of the Redemption of man through Christ's sacrifice, takes on a personal and deeply human significance [12].

Joos Vijd's brother Christoffel, knight and captain of the Land van Waas, had a military career and probably died unmarried. He and Joos had two sisters, Mabelie and Elisabeth. The descendants of Mabelie, who married Godfried Raes, Chancellor of Brabant, were to bear such distinguished names as Vilain, Montmorency, Croy, Aerschot, Hornes, Egmont, Bassignies and Hoogstraete. Elisabeth, who married Joos Triest, Lord of Ten Walle in Beveren Waas, was among the forebears of Antoon Triest, a bishop of Ghent in the seventeenth century. A Louis Vijd, who went to France with Philip the Good in 1421 to avenge the death of Jean sans Peur, and a Jan Vijd mentioned in a list of noble families of the Land van Waas compiled in 1429 when the founding of the Order of the Golden Fleece was in prospect, were also relations of Joos Vijd. Joos Vijd himself was a member of the Ghent city council a number of times: in 1395–6, 1415–16, 1425–6 and 1430–31. During the official year 1433–4 he was Ghent's principal alderman, the equivalent of a burgomaster at that time. In 1425–6 he was a member of Philip the Good's suite on his journey to Holland and Zeeland and was also one of his emissaries to Utrecht. In 1434, as a vigilant upholder of the established order, he averted a conspiracy.

Elisabeth Borluut came from a Ghent patrician family of standing. A Jan Borluut had taken part in the second crusade (1146). Another

12. Slightly enlarged detail of the *Joos Vijd* panel

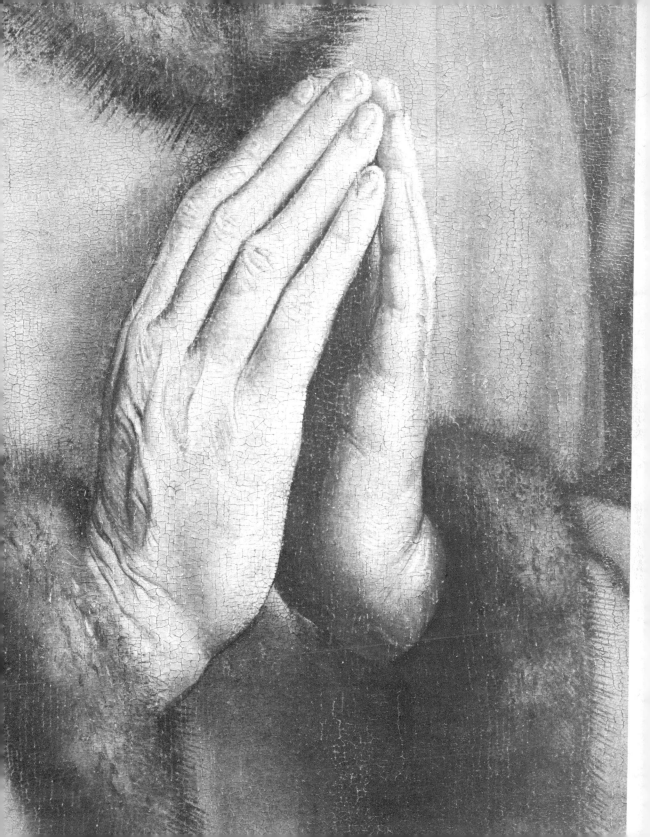

Jan Borluut, who took part in the Battle of the Golden Spurs (1302), was described as a most valiant knight (*miles fortissimus*). Other members of the family were abbots of St Bavo's Abbey in their day. Gerelmus Borluut, Elisabeth's great-grandfather, had founded the monastery of the Augustinian Eremites and the church of St Stephen, Ghent, on his return from the University of Paris. Her father Geerom Borluut, like Joos Vijd, was an alderman of Ghent a number of times.

Though there were richer men in Ghent, Joos Vijd was wealthy. In 1436-7, as a burgher of the city, he paid an 'enforced loan', a form of tax, of fifteen pounds gross (the highest recorded at this time was thirty-two pounds and the lowest five pounds).[20] In addition to the chantry at St John's he instituted an important charitable foundation, a hospice to be kept by Trinitarian monks at Beveren Waas. This he founded about 1414 when he was concerned with land reclamation at Beveren. The nature of the Trinity was perhaps reflected in the allocation of the foundation's income, for one third was to be spent on lodgings for poor pilgrims, one on ransoming Christian slaves, and one on the upkeep of the buildings. The provision for the ransoming of Christians brings the unsuccessful expedition of Jean sans Peur against Sultan Bayezid I to mind. This led to the imprisonment of the duke and his followers at Nicopolis (1395-7). Whether some member of the Vijd family took part in this expedition is not known, though in view of the Vijds' relations with Jean sans Peur it is not improbable.

It is significant for the Ghent Altarpiece that Joos Vijd and his wife had no children to pray for their souls after their death. The provision of a foundation in the hope of attaining eternal salvation for the donor and his ancestors was of special importance in their case. As one who had experience in church administration as well as in civic affairs Vijd must, moreover, have been aware of the speed with which memorial foundations may be forgotten and their works of art removed or destroyed, when the donors leave no descendants

able to look after them. His having no children was surely an added reason for endeavouring to ensure the perpetuity of the Vijd chantry by means of the deed of registration of 1435, in which the obligation to maintain the chantry was stressed, and by the provision of a work of art so splendid as to make a deep impression on those responsible for it.

Though the quatrain does not state that Joos Vijd commissioned the Altarpiece from Hubert van Eyck but only that he asked Jan to complete it, this in no way implies, as has sometimes been supposed, that the work was first commissioned by another patron.[21] Nor does the Altarpiece's nobility and splendour, or the representation on it of the tower of Utrecht Cathedral (which is in fact a repaint), suggest that the original commission was given by William IV, Count of Holland, his brother John of Bavaria, Philip the Bold or Philip the Good. Though their power had been declining for many years the patricians of Ghent were still important in the fifteenth century and the arts were still patronized in the city on a sumptuous scale. Joos Vijd and Elisabeth Borluut were both rich enough and devout enough to commission a work of this kind. Moreover both the central theme of the Altar, which is linked with Ghent's patron Saint, John the Baptist, and the presence in the Adoration scene itself of St Livinus, another patron of Ghent, give strong grounds for supposing that the Altarpiece was connected with the city from the start. In addition there are allusions to the donors and their families both in the general conception of the work and in some unusual features of the iconography.

From what is known of his life and from the study of his features [3] it appears that Vijd was thoughtful and far-sighted, astute, sober and conscientious, and well-fitted to bear responsibility. He seems to have believed in supporting the established order and to have found fulfilment within its bounds. His wife [13], in her turn, gives the impression of being intelligent, upright, and level-headed. In her day women in Ghent might achieve a high intellectual level,

as the great interest of many of them in manuscripts shows. We may suppose that this childless woman had been able to develop her powers to the full in such a setting and that she would have taken an active part in determining the nature of the foundation. She and her husband appear to have been well-matched and to have been able to look back on lives lived according to the laws of God and of society. It is not unlikely that the Altar embodies a thanksgiving for this.

Joos Vijd died between 31 March 1439, when he is mentioned for the last time as a churchwarden of St John's, and 18 December of that year, when Elisabeth Borluut is referred to as a widow. His grave has not been traced; we do not know whether he was buried in his chapel, in the crypt below it, or with his father at Rooigem. Elisabeth Borluut, who died on 3 May 1443, was buried with her family in the church of the Augustinian monastery at Ghent.

The travel notes of Münzer and De Beatis, and the writings of Lucas de Heere, Marcus van Vaernewyck and others, point to an unbroken tradition confirming the statement in the dedicatory verse that two painters worked on the altar: first Hubert van Eyck and then his brother Jan. De Heere and Van Vaernewyck state specifically that the brothers came from Maaseik, and both are astonished that such an insignificant place should have produced such eminent painters. Van Vaernewyck places Maaseik 'in the land of Kempen'. This may refer to the natural area, partly in the actual Belgian province of Limburg, which formed part of the Bishopric of Liége. Or he may well refer to the German city of Kempen which lies between the Maas and the Rhine and is not far from Maaseik. A linguistic analýsis of notes which Jan van Eyck made on the portrait drawing in Dresden generally accepted as representing Cardinal Albergati shows that Jan at least had connections with the Maas areas.[22]

Three brief references in the city archives confirm that Hubert worked in Ghent. The year of his death, 1426, is also mentioned in

13. True-scale detail of the *Elisabeth Borluut* panel

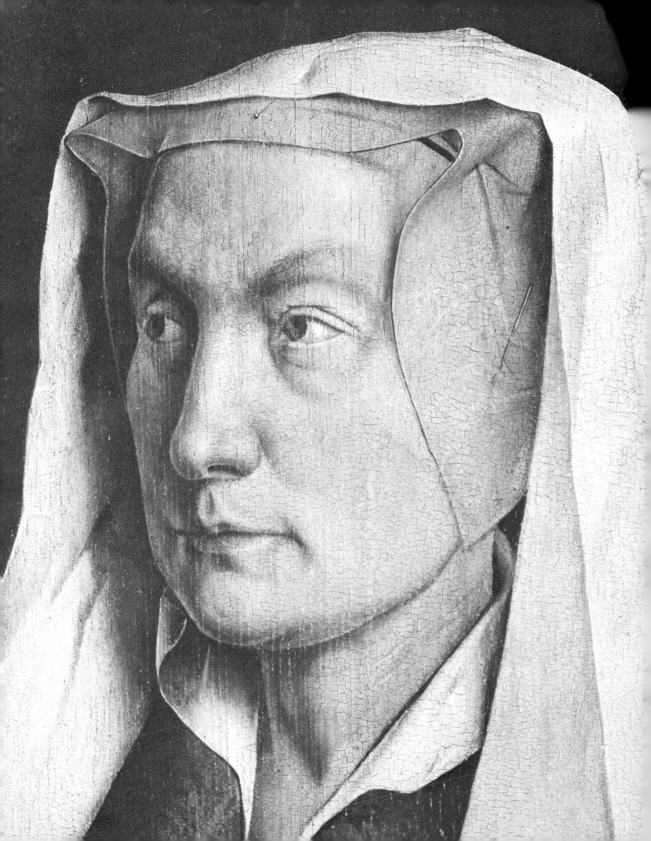

the archives. The nature of these records, which are terse and factual, suggests that they are trustworthy. One of these references relates to an altarpiece for a chapel built by the Ghent patrician Robrecht Poortier in St Saviour's, near the Abbey of St Bavo; in a document of 9 March 1426 this work is mentioned as still being in the workshop of 'Master Hubrechte the painter'.[23] Another reference, in the city accounts for the year 1424–5, relates to a payment made to a 'Master Luberecht' for two designs for an altarpiece commissioned by the aldermen; a third reference, in the accounts for 1425–6, concerns a gratuity given by the aldermen out of civic funds to the pupils of 'Master Ubrecht', perhaps on the occasion of a visit to his workshop.[24] Master Hubrechte the painter, Master Luberecht and Master Ubrecht are clearly the same person; such variants of proper names are found even today and the name Hubrecht seems to have been rare in Ghent (e.g. it does not occur in the *obituarium*, or register of memorial foundations, of St John's Church). There can be no reasonable doubt that this master is the 'Hubertus eeyck' (Hubrecht, or in English Hubert, van Eyck) of the quatrain. It is also reasonable to assume that this Hubrecht, or Luberecht, is the 'Lubrecht van Heyke' who, according to our fourth archival reference – a record of tax paid to the city by his heirs in right of succession or 'issue' – died in Ghent at the beginning of the official year 1426–7.[25] Since the official year began on 15 August this last record goes some way towards confirming the date of Hubert's death given in his epitaph: 18 September 1426.

Hubert van Eyck was buried in St John's Church. From statements made by Münzer in 1495 ('Moreover the master of the retable is buried before the altar') and by De Heere in 1559 ('He lies buried here') it seems likely that in their time his gravestone was in the Vijd Chapel, either set in the floor or, as Carel van Mander wrote in the first years of the seventeenth century, 'in a wall'. His burial in the chapel would be in keeping with the high esteem, reflected in both the quatrain and the epitaph, in which Hubert was held. Van Vaernewyck, though he gives no exact indication of the gravestone's

position, describes it as a stone slab in which a white marble skeleton holding a metal plate engraved with the epitaph was inlaid. When it came to light in the church during nineteenth-century restorations the slab was recognized from this description, though both the skeleton and the metal plate, which was doubtless of brass, were missing. The text of the epitaph is known today from Van Vaernewyck's transcript.

The Ghent Altarpiece is the only work in which Hubert van Eyck had a share, so far identified. This need not surprise us, for we have the names of many painters of his time whose works remain entirely unknown.

More is known of the working life of Jan van Eyck than that of his brother, since he is mentioned in the records of the households of two princes (in which, once more, the name is spelt in various ways). One set of accounts shows that Jan was working in The Hague in the service of John of Bavaria, Count of Holland (d. 6 January 1425), from at least 24 October 1422 to 11 September 1424. He later entered the service of Philip the Good, Duke of Burgundy. As his court painter, 'varlet de chambre', and trusted courtier he was charged with secret missions and undertook long journeys. In 1425 he was in Bruges and Lille. In July 1426, and from August to 27 October of the same year, he was again travelling. In 1427 he was in Tournai. In February 1428 he returned from further travels. On 19 October 1428 he began his long journey to the Iberian peninsula, from which he returned to Sluis on 25 December 1429. Finally, after Philip's marriage to Isabella of Portugal on 7 January 1430, he settled at Bruges, where he himself married. There he carried out work both for the city and for private patrons. He died on 9 July 1441. He seems to have remained in touch with Ghent throughout his life, for his daughter was christened Lievine, which suggests that one of her godparents came from Ghent. There is, moreover, evidence which may suggest that Jan van Eyck's *St Barbara*, now in the Museum voor Schone Kunsten, Antwerp, was commissioned by a Ghent patron.

In the earliest references to Jan van Eyck, that in the dedicatory
verse excepted, the Ghent Altarpiece is not mentioned. His name is
connected with it for the first time in a literary source in De Heere's
ode of 1559. When Dürer mentioned *des Johannes Tafel* in 1521 he
was referring to the Altarpiece not as by Jan van Eyck, but as being in,
or belonging to, the church of St John, for he alludes to the church's
tower in a similar way. (Münzer had already referred to the Altar-
piece as the painting *ad Ioannem*: i.e. as the painting in St John's
Church.) Jan's work on the Altarpiece, which can be dated between
the end of 1426 and 6 May 1432, must have been subject to constant
interruption. As Münzer tells us, he received the handsome sum of
six hundred crowns on completing his task. Vijd spared no expense,
and Jan was used to receiving generous payments.

The circumstances of Jan's life and artistic production differed
from those of Hubert; this in itself may reflect differences of character
between the two brothers. Jan's readiness to travel, which fitted him
to accompany a court constantly on the move, and his ability to carry
out diplomatic missions, imply an astute knowledge of his fellow
men and the worldly wisdom to which his portraits also testify [14].
Hubert, though he too may have travelled, was perhaps more con-
templative, more bound up with the religious and civic traditions
of his own setting and time, and well suited by these qualities to
execute a commission such as that given by Joos Vijd.

14. *Portrait of a Man with a Turban*, 1433. Jan van Eyck

THE CHAPEL'S INAUGURATION AND ITS FURNISHINGS

The chronogram in the last line of the dedicatory inscription gives
the date 6 May 1432 (not 16 May, as some writers have supposed).
The significance of this chronogram is evident. It records the day
on which the donors handed over the chapel 'with the chalice, the
missal, and the ornaments' appertaining to it to the church auth-
orities. The choice of 6 May was not due to chance, for this day,
which was a holy day of obligation in the Bishopric of Tournai, of
which Ghent still formed part, is the feast of St John in Oil, or at

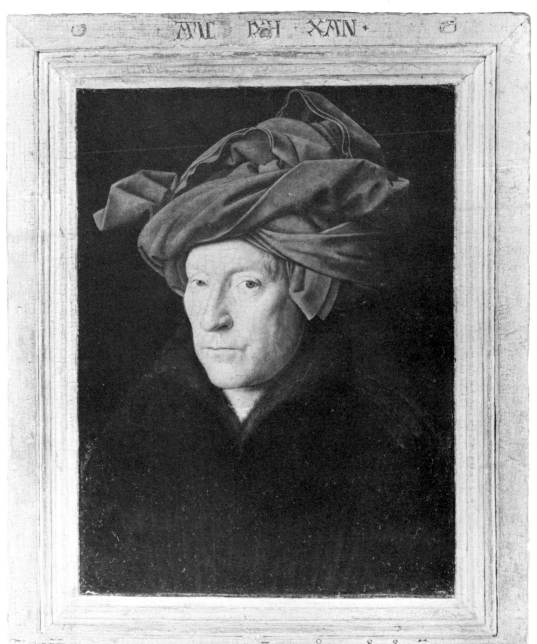

the Latin Gate, the feast, thus, of the apostle and evangelist whose writings inspired many features of the Altarpiece. The donors kneel before this saint, St John the Evangelist [15], as well as before St John the Baptist, the patron saint of the church, in the Altarpiece itself.

In 1432 this date was doubly appropriate, for the son born in Ghent to Philip the Good and Isabella of Portugal on 24 April of that year (who was to die as an infant on 21 August) was christened on 6 May. We may take it that, according to custom, he was christened at St John's Church, where Charles V was later baptized. The Bishop of Winchester[26] conducted the service and the child was given the name Joos. Joos Vijd must have chosen the date for the inauguration of his chapel in consultation not only with the city authorities and the clergy, but also with members of Philip's court. The duke himself was not in Ghent when the two ceremonies took place, but since both Joos Vijd and Jan van Eyck had close connections with his court we may suppose that he visited the chapel later. The viewing of the Altar during Vijd's lifetime was accompanied by some formality, for we know that when the abbot of St Peter's, Ghent, wished to see it in November 1433 he first paid a visit to the distinguished donor.[27] The chapel had probably been separated from the ambulatory by wrought-iron railings by the time the ceremonies of May 1432 took place. These railings had certainly been set up by 1435, for when in 1435, 1439 and 1440 the church authorities, among them Joos Vijd as a churchwarden, concluded agreements with the Ghent Bakers' Guild about the furnishings of their chapel, it was stipulated that this should be closed by railings like those of the Vijd chapel, which adjoined the bakers' chapel on the western side.[28] Candles, presumably bearing the donors' arms, were burned on certain occasions above the railings of the Vijd chapel, for the bakers were required to burn three candles bearing the guild's arms, above their railings, at the same times. The railings probably stood more to the north than the present marble structure, perhaps even projecting into the ambulatory, to enable the wings of the polyptych

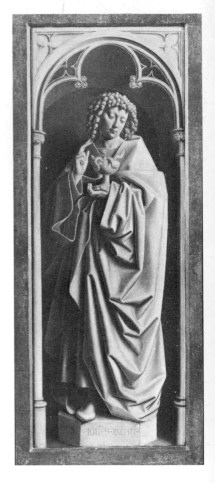

15. The *St John the Evangelist* panel

to be fully opened [62]. Originally the Altarpiece was considerably higher than it is now.[29] The altar-table was certainly higher than the present one, in keeping with the proportions usual in the church during the fourteenth to sixteenth centuries; there was a predella and an intermediary register with a central tabernacle for the reservation of the Eucharist. And the whole was crowned by a sculptured baldachin, remnants of which survived until the nineteenth century (1885–7). Archaeological evidence concerning the tabernacle and the baldachin remained hidden behind the baroque aedicule which framed the Altarpiece until 1950–51.[30]

The door of the tabernacle must have been situated in the wall behind the Altarpiece, i.e. in the Bakers' Chapel, and this wall may have been adorned with a Holy Trinity of which a reminiscence appears to have survived in the painting of G. De Crayer which hung there from about 1633 until it was removed in 1950–51.

The form of the iron hinges on the wing panels of the Ghent Altarpiece (known from old photographs and from those still partly surviving) suggests that the retable itself was constructed like a cupboard or case so that, when open, the central panels were recessed. This would explain some apparent discrepancies in the composition, especially in the panels of the lower register. For when seen on the same plane, as they are today, the horizon line does not follow through evenly: but it would do so if the central panel were slightly recessed.

It was laid down in the deed of registration of 1435 that one of the minor clergy was to be responsible for opening and closing the chapel. We do not know whether the Altarpiece itself was completely opened each day, but a fixed cycle corresponding with the liturgical year was probably observed. Opening and closing the work must have involved considerable manipulation,[31] but the way in which this was done can not now be traced with certainty.

The 'ornaments' which Vijd provided for the chapel, in addition to the chalice and the missal, must have included candlesticks and

other such adornments, as well as praying-desks and perhaps benches for the donors and others attending the mass. From a collection of memorial inscriptions assembled by a Joos Borluut, which is dated 1555, we know that the donors' arms were represented in the glass of the windows.[32] This glass, which was still in place in 1772, has now perished, but the Vijd and Borluut arms carved in the vaulting, which were doubtless painted and gilded, remain. Clearly the setting was splendid. This, as well as the legal registration of the foundation and the magnificence of the work itself, must have contributed to the Altarpiece's preservation.

1 Themes and their Early Sources

When the polyptych is closed [2] its main subject is the Mystery of
the Incarnation. In the paintings of the top register [16] prophets
and sibyls are shown: Zechariah and Micah, as half-length figures
in niches, in the left- and right-hand panels, and the Erythraean

16. The *Annunciation* panels

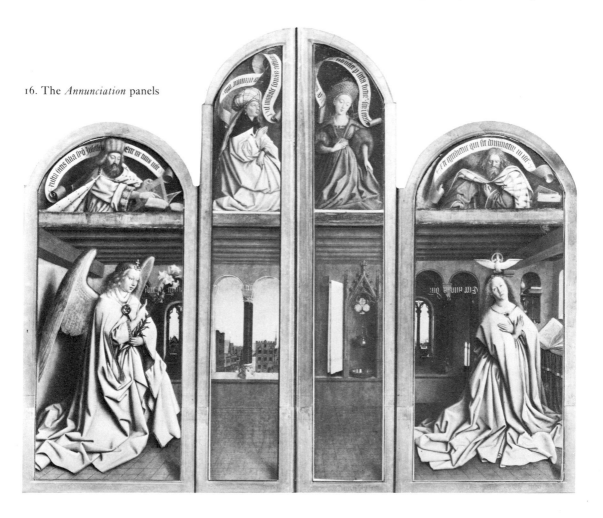

and Cumaean sibyls, who kneel in a shared niche in the taller panels in the centre. These figures, whose names are painted below them on the frames, remind us that the birth of Christ was foretold in the Old Testament and by pagan antiquity. In the inscriptions which accompany them Christ's role as the King who shall come to reign is emphasized. SACHARIAS PROPHETA [60], to the left, points to the text of his open book. The passage from his prophecies written on his scroll is given in shortened form: EXULTA SATIS FILIA SYON JUBILA ECCE REX TUUS VENIT, 'Rejoice greatly, O daughter of Sion; shout, [O daughter of Jerusalem:] behold, thy King cometh unto thee' (Zechariah ix, 9). The scroll of MICHEAS PROPHETA [10], to the right, bears the text: EX TE EGREDIETUR QUI SIT DOMINATOR IN ISRAEL, 'Out of thee shall he come forth unto me that is to be ruler in Israel' (Micah v, 2). The curling scroll of the SIBILLA ERITREA is inscribed with words based on Virgil's *Aeneid* (vi, 50-51): NIL MORTALE SONANS AFFLATA ES NUMINE CELSO, 'He speaks with no mortal tongue, being inspired by power from on high'. The scroll of the SIBILLA CUMANA bears words adapted from a quotation from the Sibylline Oracles (VIII, 217 ff.) given by St Augustine in his *De Civitate Dei* (XVIII, 23): REX ALTISSIMUS ADVENIET PER SECULA FUTURUS SCILICET IN CARNE, 'The King Most High shall come in human form to reign through all eternity'. On the Cumaean sibyl's bodice the word MEIAPAROS, whose meaning is uncertain, appears; some writers have regarded this as an indication that the sibyls' names were exchanged when these were painted on the frames.

Below the prophets and sibyls, in the middle register, the Annunciation is represented (Luke i, 28-38). This was a traditional subject for the outside of altarpieces made to open and close, since it was related to many themes from the gospels which might be shown on the inner panels. It was also suited to compositions with a caesura at the point where the closed wings met. In the Ghent Altar the Annunciation represents the beginning of the Redemption, itself the general theme of the work when open: at the moment of

the Annunciation the Second Person of the Trinity, Christ the Redeemer, entered the world.

The Virgin's room is represented in the four panels of the middle register in such a way that the frames form, as it were, an open wall through which we witness the event. The archangel Gabriel's message [65], coming out of his mouth and written in golden letters, hovers in the air: AVE GRACIA PLENA DOMINUS TECUM, 'Hail, thou that art highly favoured, the Lord is with thee'. Mary's answer, ECCE ANCILLA DOMINI, 'Behold the handmaid of the Lord', is written upside down in order that the Holy Spirit, who appears above her in the form of a dove, may read it [51]. The lighting of the room, and certain objects that it contains (the bottle of water on which the sunlight plays [17], and the lavabo [68]), have symbolic

17. True-scale detail of one of the *Annunciation* panels

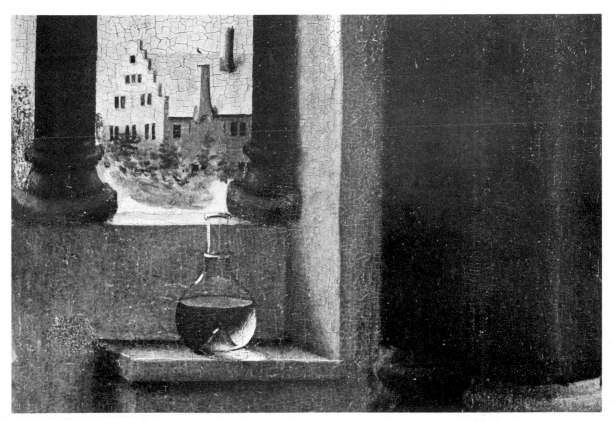

meanings connected with Mary's virgin motherhood. In the book on her *prie-dieu* is a reference to the text: 'That I should build him an house' (II Chronicles ii, 6). This must relate to Christ's incarnation in the Virgin's womb. It may refer in addition to the building activities of the chapel's founders and to the reservation of the Eucharist in the tabernacle.

In the central panels of the lower register of the closed Altarpiece St John the Baptist and St John the Evangelist are shown as statues in niches. Joos Vijd and Elisabeth Borluut, also shown in niches but as though in life, kneel before these saints in devotion and, at the same time, in permanent adoration towards the Sacrament in the middle of the intermediary register. Though of another era, they

18. True-scale detail of *The Adoration of the Lamb* panel

19 (*opposite*). Detail of *The Adoration of the Lamb* panel

associate themselves with these contemporaries and eye-witnesses of Christ made Flesh and of the Redemption. Apart from the deep glow of the donors' garments the outside of the Altarpiece is for the most part painted in grey and muted tones which set off the brilliance and power of the paintings of the open polyptych by contrast.

When the wings of the Altarpiece are opened [1] the principal painting of its complex scheme, the Adoration of the Lamb itself [colour plate pull-out at end of book], whose main theme is based on the Book of Revelation, is seen at the centre of the lower register. The Adoration takes place in the flowery meadows of paradise [18, 19, 29], which are surrounded by shrubs, groves, tall palm trees and conifers, and have hills and a river beyond them. The scene is spread

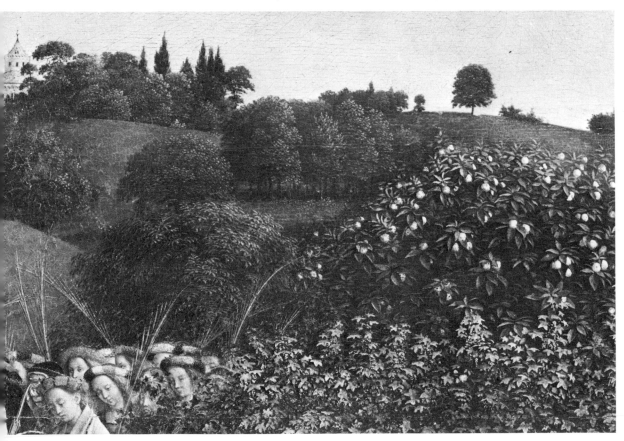

out before us as though we see it from a high viewpoint. The Lamb of God stands on an altar in the centre [8], its blood pouring into a chalice placed beside it. The Lamb symbolizes both the sacrifice of Christ, of which angels holding the symbols of the passion beyond the altar remind us, and the bloodless repetition of that sacrifice in the mass. Other angels kneel round the altar in adoration, two of them censing the Lamb of God [52], as the sacrament may be censed during the mass. The upper border of the altar's red velvet antependium bears the 'comfortable words' pronounced during the mass: 'ECCE AGNUS DEI QUI TOLLIT PECCATA MUNDI', 'Behold the Lamb of God, which taketh away the sin of the world' (John i, 29). On the two *penduli* are written the words: IHESUS VIA and VERITAS VITA, 'Jesus is the Way, the Truth and the Life' (cf. John xiv, 6). In an aureole in the sky above hovers a dove, recording St John's heralding of Christ as the Lamb of God: 'I saw the Spirit descending from heaven like a dove' (John i, 32). In front of the altar bearing the Lamb stands the Fountain of the Water of Life [52, 53], the *Fons Vitae*, a symbol of the mass which pours forth grace without ceasing. From this fountain, which is octagonal, the water flows towards the lower edge of the painting, thus in the direction of the altar of the chapel itself, at which Vijd's mass was celebrated. Round the edge of the fountain is the inscription: HIC EST FONS AQUE VITE PROCEDENS DE SEDE DEI + AGNI: 'This is the fountain of the water of life proceeding out of the throne of God and the Lamb' (cf. Revelation vii, 17, xxi, 6, xxii, 1 and 17).

The 'great multitude, which no man could number, of all nations, and kindreds, and people, and tongues' of whom St John writes in Revelation (vii, 9) surrounds the Lamb of God in the fields of paradise. Prophets and patriarchs [20] stand or kneel in a group on the left, together with those 'which were sealed . . . of all the tribes of the children of Israel' (Revelation vii, 4). A man in the foreground dressed in blue, who carries a leafy twig, is either Jesse, or Isaiah, who prophesied: 'There shall come forth a rod out of the stem of

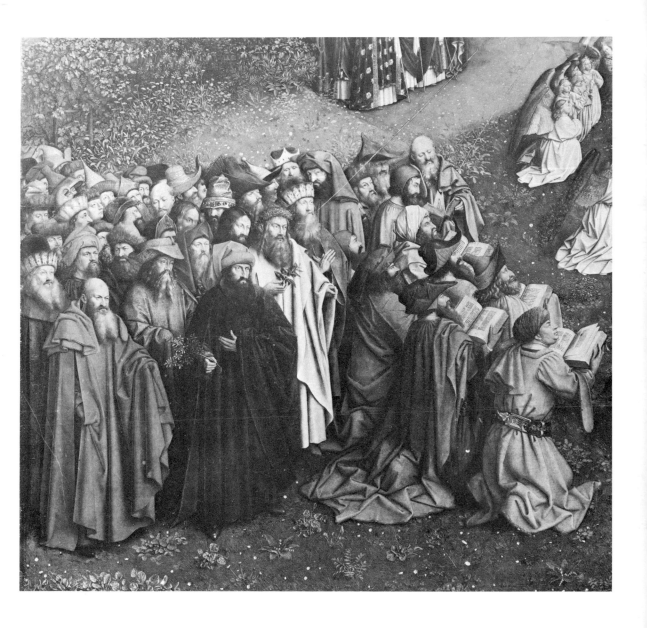

20. The Prophets and Patriarchs, detail of *The Adoration of the Lamb* panel

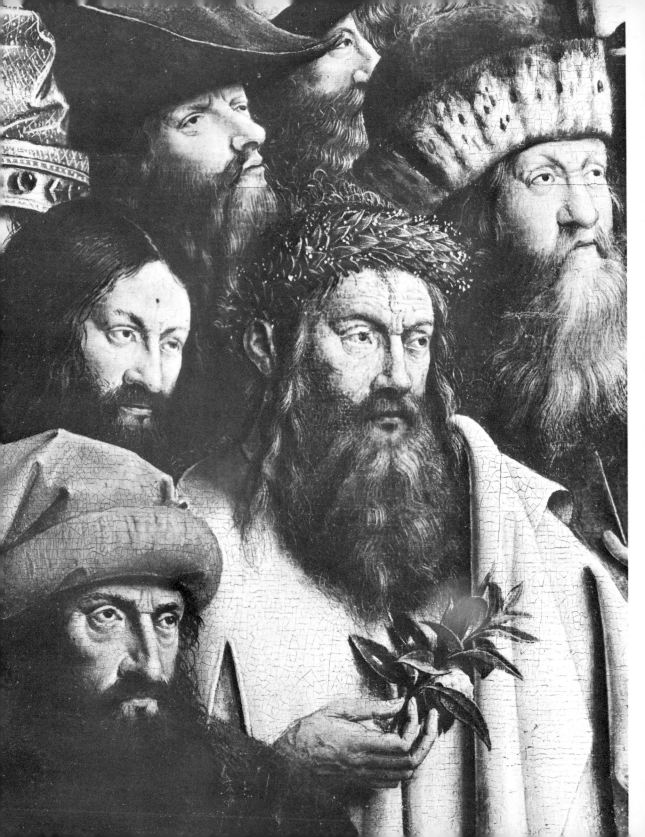

Jesse' (Isaiah xi, 1). Virgil [21], who not uncommonly was included among the prophets (and here, as we have seen, provided the words written on the Erythraean sibyl's scroll), stands behind him, wearing a white robe and the poet's laurel wreath, and holding a sprig bearing a citrus fruit. This sprig and the rod of Jesse in his neighbour's hand present a parallel between pagan antiquity and the Bible. The left-hand group of figures, which represents those who lived before the coming of Christ, is balanced on the right by figures representing the Apostles and other members of the Church [22],

21 (*opposite*). Slightly enlarged detail of *The Adoration of the Lamb* panel

22. Apostles and Clergy, detail of *The Adoration of the Lamb* panel

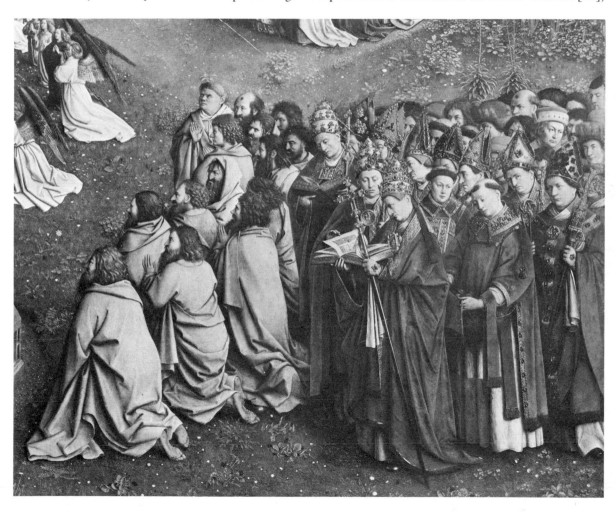

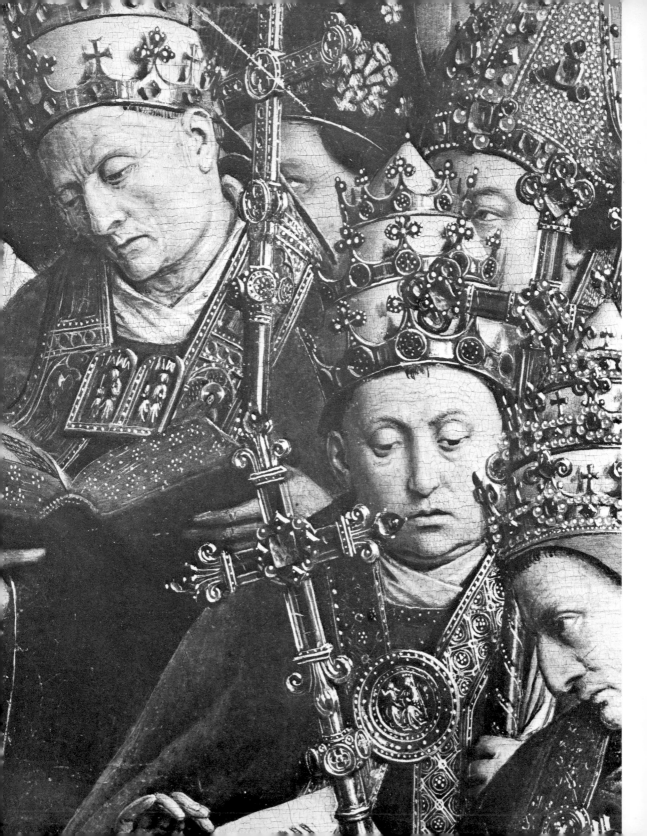

both clerics and laymen. Three of the leading Apostles can be recognized by their traditional features as St Peter, St Paul and St John. St Peter, who stands nearest to the altar, expresses his devotion to the Lamb by the direction of his glance and by a gesture which, at the same time, draws our attention to the central theme. Among the clergy are three Popes [23], recognizable by their papal tiaras. In these figures allusions can be traced to Martin V (seen in profile), Alexander V and Gregory XII, Pope and Antipope alike being admitted to heavenly bliss. The only members of this group identified by attributes are the martyr saints Stephen and Livinus. A small group of figures to the left in the middle distance, most of whom wear blue robes over white surplices, is made up of confessors and representatives of the contemplative life [24]. In the correspond-

23 (*opposite*). Slightly enlarged detail of *The Adoration of the Lamb* panel

24. The Confessors, detail of *The Adoration of the Lamb* panel

25. The Female Saints, detail of
The Adoration of the Lamb panel

26 (*opposite*). True-scale detail of
The Adoration of the Lamb panel

ing group to the right female saints [25] and martyrs are shown,
among whom the following can be recognized: St Agnes, who car-
ries her Lamb, St Barbara, with her tower, a princess who is un-
doubtedly St Catherine though she has no specific attribute, St
Dorothy with her basket of flowers, and St Ursula, who holds an
arrow and, as it seems, is followed by the eleven thousand virgins,
her companions. Two members of the group are abbesses, for they
carry croziers. Near these holy women great white lilies are in
bloom, symbolizing their virginity [26].

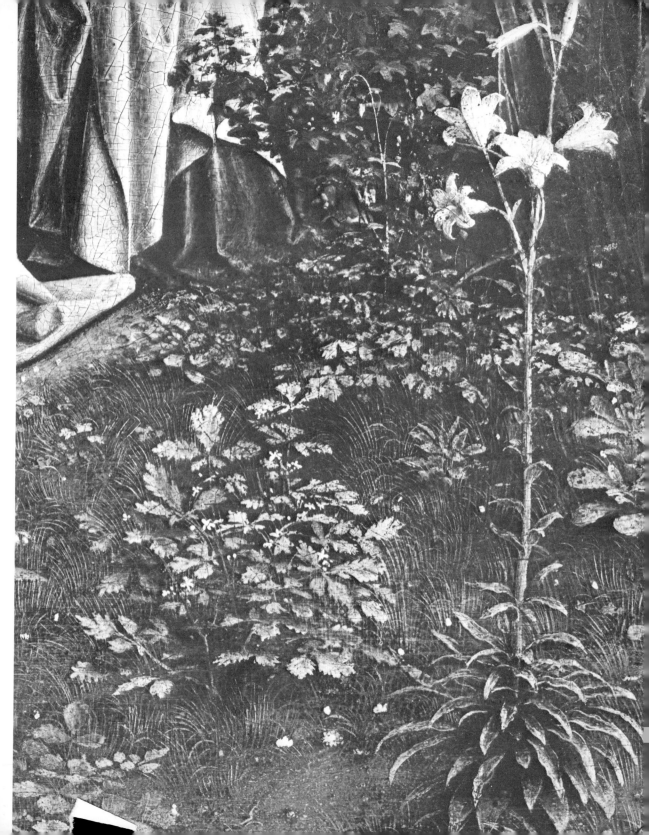

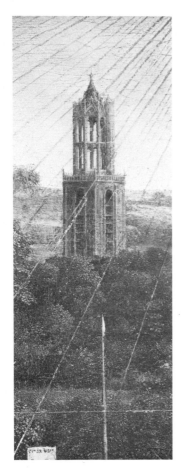 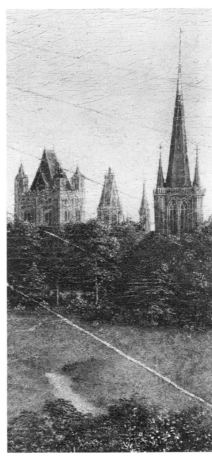

27 (*far left*). The Tower of
Utrecht Cathedral,
detail of
The Adoration of the Lamb panel

28 (*left*). The Tower of
St Nicholas Church, Ghent,
detail of
The Adoration of the Lamb panel

In the distance, behind these groups of the elect, are buildings which must represent the New Jerusalem, the city where the blessed rest in the sight of God (Revelation iii, 12 and xxi, 2). These buildings evidently symbolize the Kingdom of Heaven of the Beatitudes (Matthew v, 1–12; Luke vi, 20–23). A number of early texts connected with the Ghent Altarpiece state or imply that its programme included this theme: the description of a *tableau vivant*, presented in the open space in Ghent known as the Poel in 1458 (a show largely inspired by the Altarpiece itself),[33] Münzer's account of 1495, De Heere's ode of 1559, and a list of the church's stained

glass windows dating from about 1600.[34] In this list the Altarpiece is mentioned as one on whose inner panels 'the Beatitudes are shown', though its other themes are not referred to. The buildings of the New Jerusalem [71] must have been compiled from reminiscences and sketches, for though they include features from the Romanesque architecture of the Maas and Rhine area it seems that scarcely any real buildings are shown. Only the towers of the Utrecht Cathedral [27], and of St Nicholas's, Ghent [28], can be identified. The presence of the Utrecht tower, which stands among distant trees near the centre of the panel, has caused much speculation. Some have seen it as evidence that a patron from the northern Netherlands first commissioned the work. Others have claimed that it was added by the Utrecht painter Jan van Scorel, who, with Lancelot Blondeel of Bruges, cleaned the Altarpiece in 1550. Though this detail was indeed added after the landscape was painted there is no proof that it is of later date. An explanation for its presence and its prominent position may perhaps be found in the context of a pamphlet known as *Contra turrim Traiectensem* (Against the Tower of Utrecht) attributed to Geert Groote, whose teachings, as we have seen, must have been known to the parish priest of St John's, Van Impe. In this pamphlet[35] Utrecht's vast tower was condemned as having been built to the glory of the populace, the architect, and the city government, and to astonish strangers, with funds which had been given for the care of the poor. The use of church funds in general for such purposes was also criticized. The citizens of Ghent were engaged on equally ambitious projects and may well have sought to justify their own undertakings by placing Utrecht's controversial tower among the hallowed buildings of the New Jerusalem.

The luxuriant landscape in which the Adoration of the Lamb is set [19], which is extended in the backgrounds of the pairs of paintings to either side of the central panel [30, 31], corresponds in a striking way with the conception of the ideal landscape handed down from classical literature: the *locus amoenus*, a grassy meadow with trees of various kinds, many flowers, and a splashing spring.[36]

This idea goes back through Virgil to Theocritus and Homer. Theocritus gives a description, possibly based on the vale of Tempe, of such a place, a river valley bordered by a wood, shut in on both sides by almost vertical walls of rock crowned with vegetation. The green meadows in the Adoration panel, with bushes and trees of many kinds beyond them, the tall rocks in three of the smaller panels of the lower register, the spring, or fountain, in the foreground, and the river in the distance all agree with such descriptions from the literature of antiquity. Even the precious stones in the water round the Fountain of Life may contain a reminiscence of Theocritus, in the clear water of whose stream the pebbles sparkled like silver and crystal. This is probably the first representation of the classical ideal landscape in the art of northern Europe. Trees and

29. True-scale detail of
The Adoration of the Lamb panel

30 (*opposite*). Detail of
The Holy Hermits panel

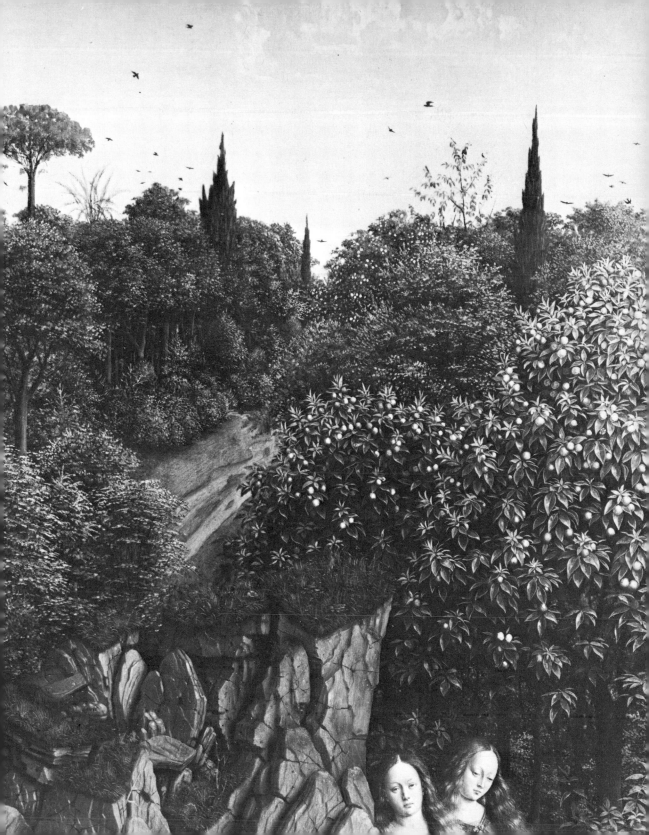

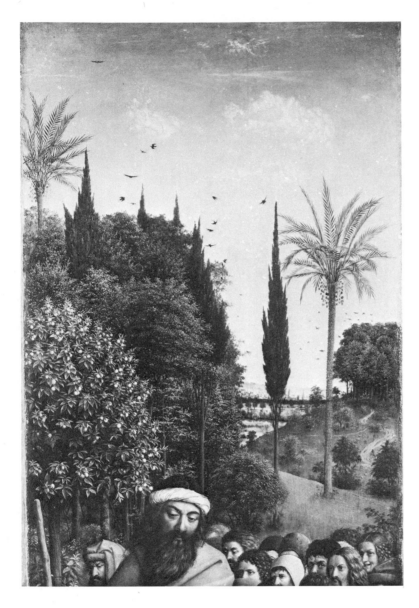

31. Detail of
The Holy Pilgrims panel

plants of different regions and flowers and fruits of various seasons
have been brought together to enhance the beauty of this ideal land-
scape, emphasizing the fact that we see not an existing, earthly,
landscape, but the perfect scenery of heaven.

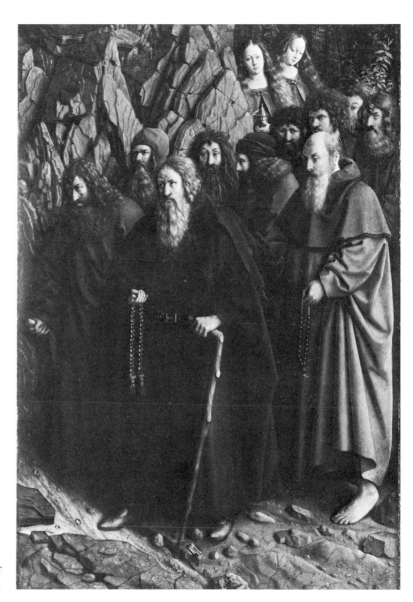

32. Detail of
The Holy Hermits panel

In the paintings to either side of the Adoration of the Lamb further
groups of figures move in the direction of the Lamb on the altar.
These are identified by inscriptions on the frames. In the panel
immediately to the right of the Adoration are HEREMITE SANCTI

[32], Holy Hermits, and in the outer right-hand panel PEREGRINI SANCTI [33], Holy Pilgrims. To the left of the Adoration are CRISTI MILITES [34], Knights of Christ, and in the outer left-hand panel IUSTI IUDICES [35], Just Judges. These categories of men, all on their way to eternal salvation, had an important place in medieval society.

The hermits and pilgrims, who are simply clad, make their way towards the Lamb on foot along a rocky track. The central figure among the hermits is St Anthony, for he has one of this saint's attributes, a T (symbolizing Christ's cross), on his habit. The hermit at his left hand is probably St Paul of Thebes, whom St Anthony visited. Nicholas Vijd and the Borluuts were benefactors, respectively, of the Carthusians and the Augustinians, both of which were hermit orders, and a number of hermits lived near the chapel of Ledeberg on the Vijds' manorial lands. Ghent's St Bavo had himself been a hermit for a time. In the middle distance are two hermitesses, one of whom is St Mary Magdalen, holding her jar of ointment; they appear from behind tall rocks to join the rest of the company. The pilgrims, who for medieval Christians symbolized the human condition with its sin, its penance, and its hope of re-demption, are led by the giant St Christopher, the patron saint of Joos Vijd's brother. One of them, who wears a scallop in his hat, may be either St Jodocus, Joos Vijd's own patron, or St James the Great, the patron of all pilgrims.

The knights and judges in the left-hand panels, some splendidly dressed in rich materials, others in glistening armour, proceed on horseback along a sandy, well-beaten pathway. These men uphold the Christian order by their deeds: the knights in military service for Christ, the judges as those to whom justice on earth is entrusted. It seems that the status and social functions of the Vijds and Borluuts are idealized in these panels: that they allude to their military careers in the service of their overlords (with the obligation to accompany them on journeys and progresses) and to the parts that they played in civic administration as manorial lords, as aldermen,

33. Detail of *The Holy Pilgrims* panel

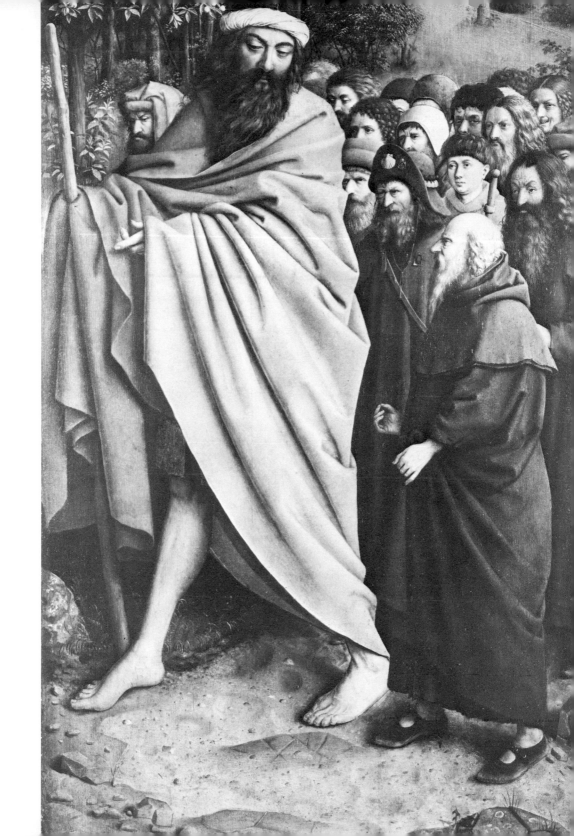

as a castellan or a bailiff. The knights are led by three young stan-
dard-bearers wearing ceremonial armour and the laurel wreath of
victory. The young knight nearest to the spectator carries the
banner of the Risen Christ: a long, tapering pennant bearing the
coat of arms (gules, a cross argent) which is also that of the Order of
Knights of St John of Jerusalem. The other young knights bear
rectangular standards: that of St George (argent, a cross gules), and
that of St Sebastian, the cross of Jerusalem (gules, a cross and four
crosslets or). The central standard-bearer carries a shield on which
is an inscription in the form of a cross, at the centre of which a T

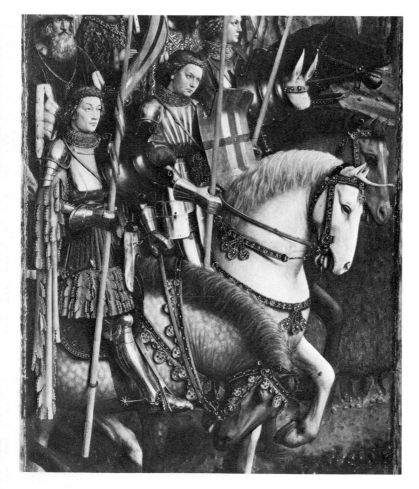

34. Detail of
The Knights of Christ panel

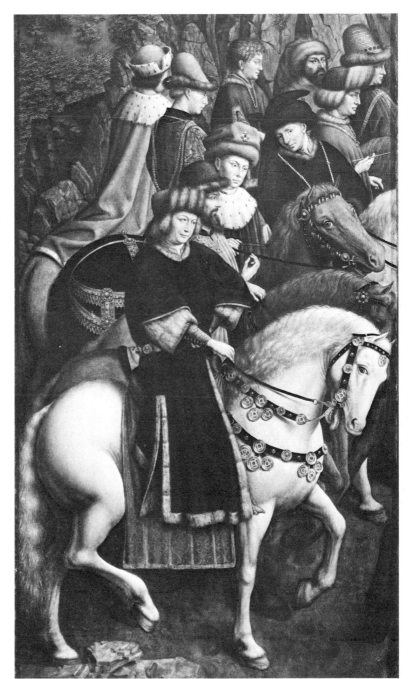

35. Detail of
The Just Judges panel

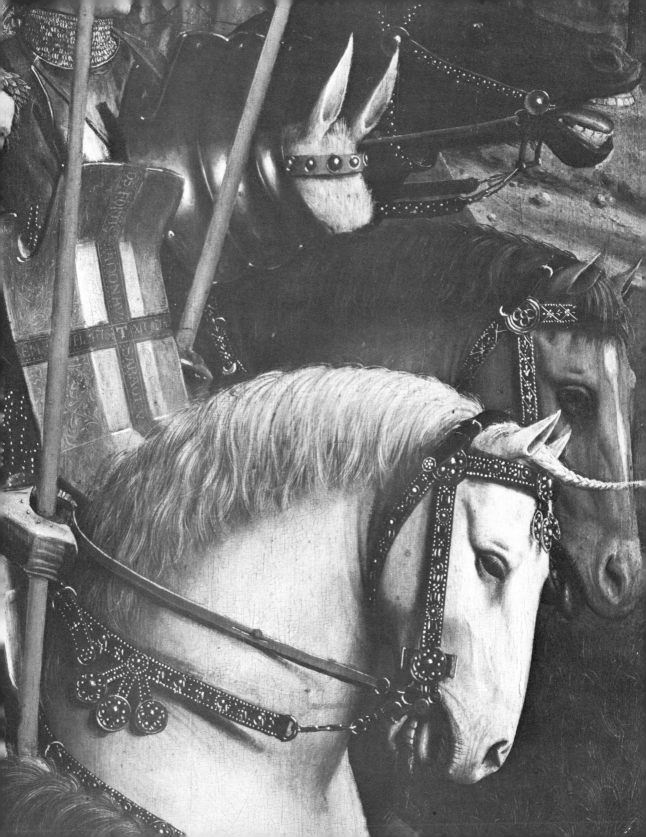

appears once more [36]. The vertical and horizontal lines read respectively: DEUS FORTIS ADONAY T SABAOT V/EMANUEL IHESUS T XPC A.G.L.A., 'Mighty God, T, Lord of Hosts, V/God with us, Jesus, T, Christ, A.G.L.A.' The V at the foot of the vertical inscription has not been explained with certainty; the T, representing Christ's cross, symbolizes the Redemption and was held to bring protection. The initials with which the horizontal inscription ends stand for the Hebrew *Atha gibbor leolam Adonay*, 'Thou art strong unto eternity, O Lord of Hosts'. Behind the standard-bearers ride six further knights, all of them royal persons or nobles. These represent knights of different ranks among the rulers of the day and at the same time must allude to a number of historical figures who have not, as yet, been identified with certainty. The scene reflects the climate of thought that led to the foundation of the Order of the Golden Fleece in 1430 and may also allude to the crusade planned, though not carried out, by Philip the Good. The present panel showing the Just Judges is a replica of the original, which was stolen in 1934 and has not been recovered. This scene too is closely related to medieval life, in which government and justice, carried out in the overlord's name, were claimed by the Church to be subject to her still higher authority. Justice was constantly brought forward at this time as a quality essential in those in authority, and this deep concern with justice frequently found expression in both literature and the visual arts.[37]

Unlike the paintings of the lower zone, those of the upper register of the open Altar do not form a unified composition. In three central panels, which are closely related in content and form, God, the Virgin and St John the Baptist are represented. In panels flanking these to either side singers and other musicians are shown. In the panels furthest from the centre Adam and Eve appear, with scenes from the story of Cain and Abel above them.

The painting in the central upper panel is of a majestic figure [37, 54] robed in scarlet seated against a golden background, his

76

right hand in a gesture of benediction, his left hand holding a sceptre and rays of light emanating from his head. The brocade shown behind this figure of the Deity bears the inscription IHESUS XPS and two symbols of Christ: the pelican in her piety, and the vine. The threefold inscription on the mouldings reads in its entirety:

+ HIC EST DEUS POTENTISSIMUS PROPTER DIVINAM MAIE-STATEM. + SUMMUS OMNIUM OPTIMUS PROPTER DULCE-DINIS BONITATEM. + REMUNERATOR LIBERALISSIMUS PROPTER INMENSAM LARGITATEM.

'This is God, the Almighty by reason of His divine majesty; the Highest, the Best, by reason of his sweet goodness; the Most Liberal Remunerator by reason of his boundless generosity.'

The description of the Deity is continued in words written on the edge of the dais on which his seat is placed, to either side of the crown [38] which lies at his feet:

VITA SINE MORTE IN CAPITE. IUVENTUS SINE SENECTUTE IN FRONTE.

'Eternal life shines forth from His head. Eternal youth sits on His brow.'

GAUDIUM SINE MERORE A DEXTRIS. SECURITAS SINE TIMORE A SINISTRIS.

'Untroubled joy at His right hand. Fearless security at his left hand.'

The way in which Christ is represented recalls the vision of Ezekiel (i, 26) and that of St John in Revelation (iv, 2, xx, 11, xxi, 5, xxii, 4). Yet here, as the High Priest, he wears the papal tiara. The words REX REGUM ET DOMINUS DOMINANTIUM, 'King of Kings, and Lord of Lords', embroidered as a repeating theme on the hem of his garment [47], are taken from Revelation (xix, 16); the word SABAωT, written on his stole, recalls both the Scriptures and the Sanctus of the mass, where, in the Latin text,

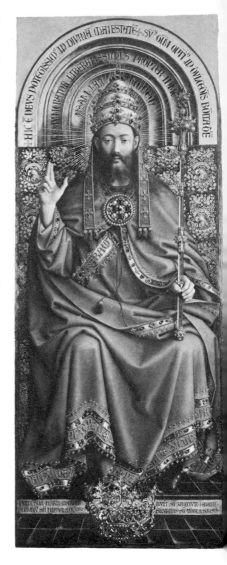

37 (*opposite*). *Christ Enthroned* panel

38. Detail of 37

God is addressed as Lord God of Sabaoth. The fixed gaze of the Deity [39], who looks out over the congregation in the chapel, recalls a passage from the First Epistle of St Peter (iii, 12): 'For the eyes of the Lord are over the righteous.' There is, indeed, a repaint in the eyes which shows that great care was taken in determining the direction of his glance. The equivalent figure in the tableau on

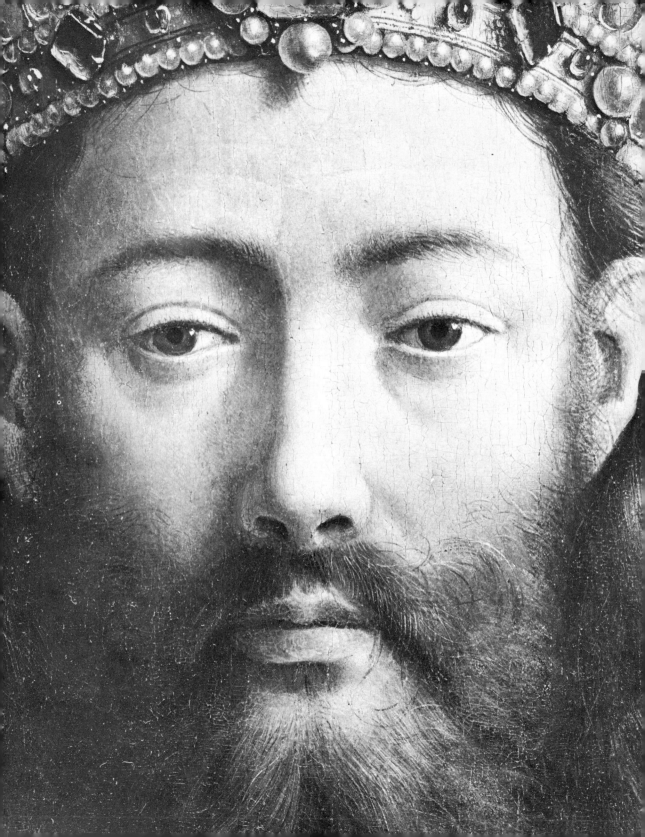

the Poel of 1458, wearing an imperial crown instead of a tiara, was described as God the Father: and the figure has been frequently (and erroneously) interpreted as the First Person of the Trinity. Allusions to God the Father and to the Trinity in certain old descriptions of the Altarpiece are perhaps to be explained by reference to a painting of the Trinity on the Bakers' Chapel side of the altar-wall, above the tabernacle door, probably in grisaille as is the

39 (*opposite*). Slightly enlarged detail of the *Christ Enthroned* panel

40 Detail of *The Virgin Enthroned* panel

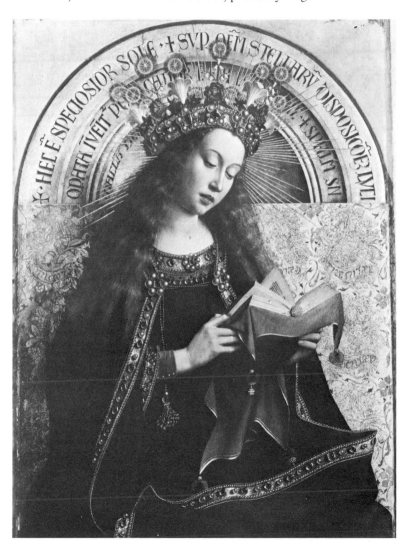

Trinity by the Master of Flemalle now in the Stadelsches Kunstin-stitut, Frankfurt-am-Main.

The qualities attributed to the Deity in the inscription, in the three phrases preceded by crosses, must relate to the three persons of the Trinity. Omnipotence and majesty are, in particular, asso-ciated with God the Father, goodness with the Son, and generosity with the Holy Ghost, the Rewarder who bestows grace on the elect. Evidently, the nature of Christ, God and Man, King and Priest, is expressed in the figure of the Deity, and the oneness of God in the three persons of the Trinity is emphasized by the inscription.

The Virgin [40, 73], represented in the adjoining panel to the left, sits enthroned at the right hand of Christ, reading her book with deep devotion. She wears a blue mantle with a gold border sewn with pearls, and a richly jewelled crown of a most unusual kind, composed not only of gold and jewels but also of fresh flowers (lilies, roses, columbine and lilies of the valley, symbolizing purity, love, meekness and humility) and surrounded by twelve shining stars. An inscription on the golden mouldings behind her reads:

HEC EST SPECIOSIOR SOLE ET SUPER OMNEM STELLARUM DISPOSICIONEM LUCI COMPARATA INVENITUR PRIOR. CANDOR EST ENIM LUCIS ETERNE ET SPECULUM SINE MACULA DEI.

'She is more beautiful than the sun and all the order of stars; being compared with the light she is found the greater. She is in truth the reflection of the everlasting light, and a spotless mirror of God.' (Wisdom vii, 29 and 26.)

She is shown, not as the mediatrix who intercedes for mankind, but as the crowned bride of the Song of Solomon, the second Eve, the Bride of Christ by whom the Church is symbolized.

At the Deity's left hand St John the Baptist sits enthroned [41, 42]. He wears a green mantle with a rich border over his camel-hair shirt and is barefooted. He too has a book but, as the herald of

41. The *St John the Baptist Enthroned* panel

42 (*far right*). True-scale detail of 41

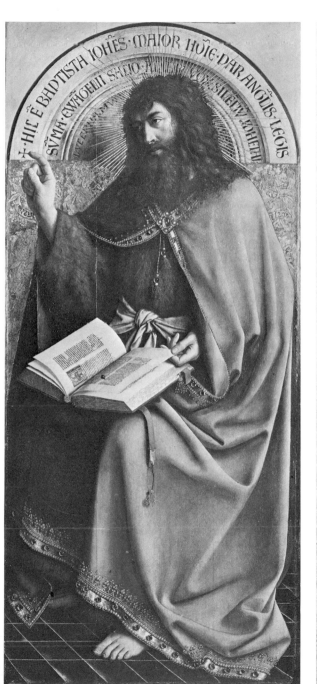

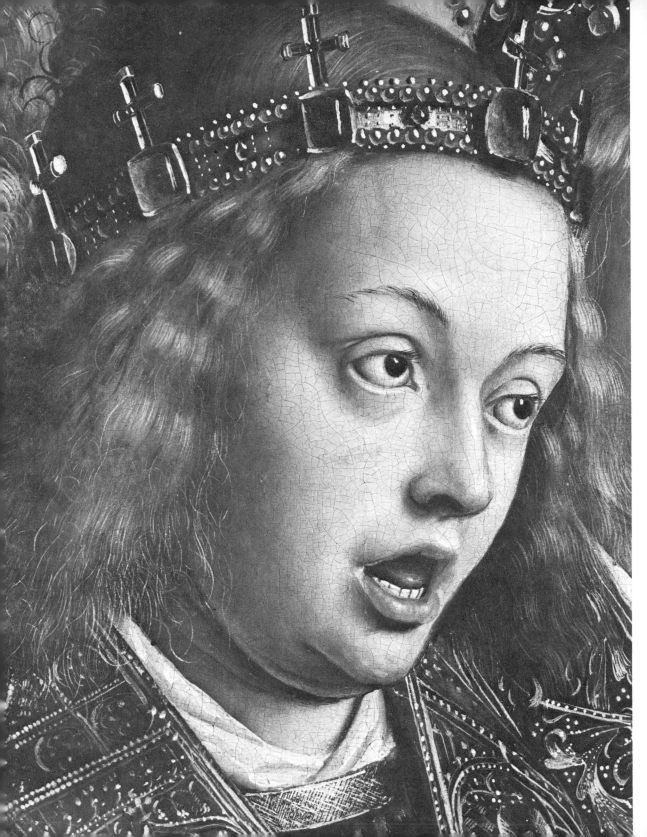

Christ who preached His coming in the wilderness, he looks to-
wards the Deity and points clearly to him. In his book [5] the
opening words of Isaiah's prophecy concerning the Baptist is
written: CONSOLAMINI, 'Comfort ye' (Isaiah xl, 1). The mouldings
behind him bear the words:

HIC EST BAPTISTA IOHANNES, MAIOR HOMINE, PAR
ANGELIS, LEGIS SUMMA, EWANGELII SACIO, APOSTOLORUM
VOX, SILENCIUM PROPHETARUM, LUCERNA MUNDI, DOMINI
TESTIS.

'This is John the Baptist, greater than man, like unto the angels, the
summation of the law, the propagator of the Gospels, the voice of
the Apostles, the silence of the prophets, the lamp of the world,
the witness of the Lord.'

The importance of St John the Baptist, as a participant in the story
of the Redemption and, in addition, as the patron of Ghent and of
the church for which the Altarpiece was painted, is stressed by this
inscription and by the place of honour accorded to him.

To each side of the central triad the Singers and Musicians are
shown [63A, B], wearing jewelled circlets on their heads and pluvials
of brocade: the Singers in the left-hand panel [43, 49], standing
round a lectern ornamented with a carved relief and with various
symbols (among which an ape, a symbol of sinful man, appears),
and an organist [44] and the players of other instruments, the
Musicians, in the right-hand panel [45]. These figures have usually
been referred to as angels, but they are depicted without wings. Pos-
sibly they contain an allusion to the liturgical choir which sings
both in the mass of the church and in the eternal mass of Christ,
referred to by Rupert of Deutz,[38] to whom we shall return. The
scenes must in any case be based on contemporary music-making.
It is known that St John's Church had singers and musicians at
this time, and the little organ shown is of a type current in the Van
Eycks' day. The floors in these panels are of splendid blue and
white Spanish tiles which contrast strikingly with the reddish

43. Slightly enlarged detail of
The Singers panel

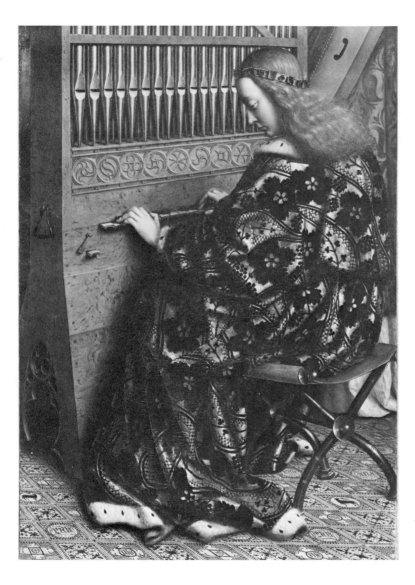

44, 45. Details of *The Musicians* panel

brown and blue-grey tiles of the floor which appears in the central
paintings. Their decorative and symbolic motifs include both the
Lamb of God and the name IECVC (Jesus), which has often been
wrongly interpreted as a Van Eyck signature. Below the panel with
the singers, painted on the frame, is the inscription: MELOS DEO
LAUS PERHENNIS GRATIARUM ACTIO, 'Songs of supplication,

songs of praise, songs of thanksgiving'. Below the musicians is the inscription: LAUDATE EUM IN CORDIS ET ORGANO, 'Praise him with stringed instruments and organs' (Psalm cl, 4).

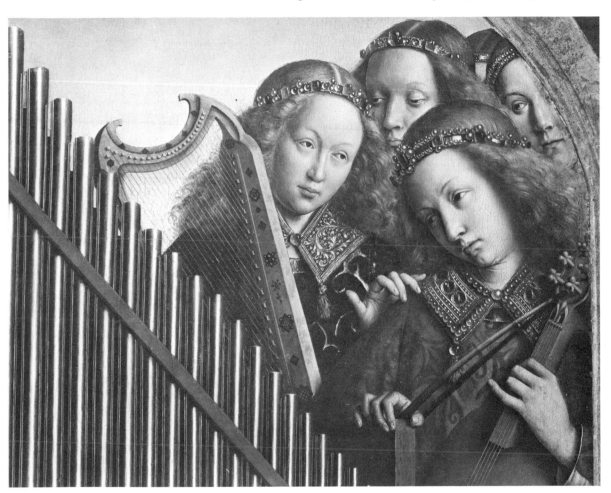

The programme of the Altar, which sums up Christian teaching and expresses the anticipation of salvation of all humanity, is complemented by the figures of Adam and Eve [56], who are shown, seemingly standing in narrow niches, in the upper panels furthest from the centre, Eve holding a fruit symbolizing the Fall of Man in her hand [46]. Since human sin began with the Fall,

their presence points to the origin and purpose of the Redemption. The inscriptions below these figures read: ADAM NOS IN MORTEM PRAECIPITAT, 'Adam thrusts us into death', and EVA OCCIDENDO OBFUIT, 'Eve has afflicted us with death'. The story of Cain and Abel [50], painted above the niches as though portrayed in sculpture, prefigures the sacrifice of Christ, which brought redemption.

Marcus van Vaernewyck tells us that the Altarpiece had a predella in which 'a hell' was represented. Of this no trace now remains. It seems clear that in fact limbo was depicted: the region to which Christ descended after His death on the Cross, to redeem those who had already died, which was often referred to as hell. The scene showing the Adoration of the Lamb was linked with the predella both compositionally and in its symbolic content, since the redeeming water springing from the Fountain of Life flowed in the direction of this part of the work. Other parts of the Altarpiece may have disappeared – and of course we do not know what they represented: but it may be mentioned that the number of figures counted in early times is given as 300 by Lucas de Heere or 330 by Marcus van Vaernewyck, many more than can be counted today.

46. Detail of the *Eve* panel

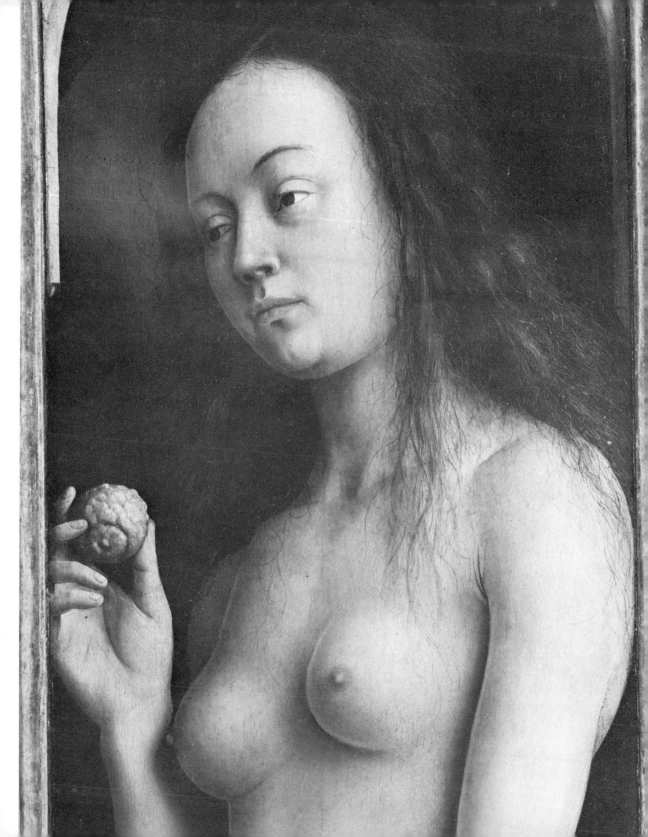

5. A Medieval Source: Rupert of Deutz

Many attempts have been made to interpret the Ghent Altarpiece by referring to texts such as the liturgy for All Saints' Day, with its familiar readings from the Apocalypse (Revelation v, 6–12, vii, 2–12, xiv, 1), the Beatitudes (Matthew v, 1–12; Luke vi, 20–23), the twelfth-century sermon on All Saints of Honorius of Autun, or the vision of the sexton of St Peter's described in the Golden Legend of Jacobus de Voragine in the thirteenth century. None of these sources, however, explains the Altarpiece in its entirety; one or more of the subjects shown is lacking in each of these texts.

To understand the Altarpiece's programme, the unity of thought that binds the work together in a chain of allusions and associations, we must return to its origin and to the function that it was designed to fulfil as part of an altar founded for the celebration of a daily mass. According to the deed registering the foundation drawn up in 1435, this mass was celebrated 'to the honour of God, His Blessed Mother and all His Saints . . . for the salvation of the souls of the founders and their forefathers'. Since it was to take place daily, it was fitting that the Altarpiece's symbolism should be related to the mysteries of the cycle of the church's year: the Incarnation (Advent and Christmas) and the Redemption (Lent, Easter and Whitsun). The theme of All Saints was also appropriate to an altarpiece of this kind. In its paintings those attending the mass could identify certain saints commemorated during the year, as well as groups of figures representing the apostles, martyrs and saints of other kinds mentioned in the canon of the mass. Though its main theme is the Mystery of the Redemption, with its corollary, the Mystery of the Communion of Saints, these subjects are interwoven with allusions to historical events, to local and family circumstances, and to personal aspirations. The salvation which the founders so earnestly

sought for themselves and their forefathers is granted through the intervention of the Lamb of God, represented on the altar at the centre of the Adoration panel. The words 'Behold the Lamb of God who taketh away the sins of the world', written on the antependium, were spoken by Ghent's patron, St John the Baptist, and recorded by St John the Evangelist. It is before these saints that the donors kneel in devotion in the panels of the outside of the Altar, at the point where, when the work is opened, the Adoration of the Lamb is revealed.

The iconographic scheme of the Altarpiece, which is unique, must have been drawn up by a scholar. The many inscriptions testify to his erudition. His knowledge of the literary heritage of the Middle Ages was clearly profound. Yet he was more than a scholarly compiler. He was a learned poet who arranged and interpreted the texts that he cited or composed new ones, sometimes giving them rhyme or rhythm. The inscriptions on the Altarpiece, moreover, form an integral part of the work as a whole, the yeast by which the whole is leavened.

In addition to the Bible the main sources for the Altar's iconography were the works of the Fathers of the Church and of classical antiquity. The figures and scenes on the Altarpiece cannot, however, be fully explained by referring to such texts alone. The author of the iconographic programme evidently made use of later commentaries; the medieval interpretation of the early sources must therefore be taken into account. The text from Revelation 'King of Kings and Lord of Lords' appearing on Christ's robe, for example [47], occurs in the *De victoria Verbi Dei* (Concerning the Victory of the Word of God) of Rupert of Deutz, a twelfth-century commentator whose writings undoubtedly influenced Christian iconography.[39] Rupert of Deutz writes: *Videte hunc regem coronatum, videte in manu ejus sceptrum, videte vestem purpuream . . . et confitebitur linguae Hebraica, lingua Graeca, lingua Latina, me regem esse Judaeorum, imo et Regem regum, et Dominum dominantium*, 'Behold this crowned king, behold in his hand the sceptre, behold his purple robe . . . and it

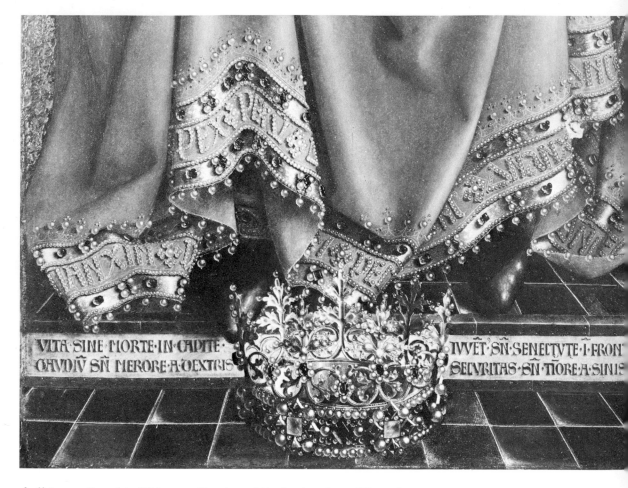

VITA·SINE·MORTE·IN·CAPITE·
GAVDIV·SÑ·MERORE·A·DEXTRIS

IVVET͂·SÑ·SENECTVTE·I·FRON
SECVRITAS·SÑ·TIORE·A·SINI

47. Detail of the
Christ Enthroned panel

shall be confessed in Hebrew, Greek and Latin that I am King of the Jews, yea even King of Kings and Lord of Lords'.[40] Though Rupert refers here to the mocking of Christ he uses terms which St John applied to the glory that was to come. His colourful descriptive words are more likely to have been a source of inspiration for the Van Eycks' remarkably concrete representation of the Deity than, for example, the passage in which St Augustine quotes the same text in his *De Trinitate* (I, 6), where he links it with St Paul's words concerning the King of Kings: 'Whom no man hath seen, nor can see' (I Timothy vi, 16).

The passage cited above is not the only one in the commentaries of Rupert of Deutz which provides parallels with the figure of the Deity in the Altarpiece. He also characterizes Jesus Christ as Magnus Pontifex, the High Priest, and states: *Deus est et homo, rex atque sacerdos,* 'He is God and Man, King and Priest'.[41] He repeatedly describes Christ in similar terms.[42] Such passages may explain the papal tiara worn by the Deity in the Altarpiece, while the crown at his feet, situated just above the tabernacle, is paralleled in words written by St Paul which Rupert cites in his commentary on the Apocalypse: 'Henceforth there is laid up for me a crown of righteousness, which the Lord, the righteous judge, shall give me at that day: and not to me only, but unto all them also that love his appearing' (II Timothy iv, 8).[43] Rupert's references to passages in Ezekiel and Isaiah concerning God also correspond with the Van Eycks' Deity: *Deus ego sum et in cathedra Dei sedi,* 'I *am* God, I sit *in* the seat of God' (Ezekiel xxviii, 2); *Vidi Dominum sedentem super solium excelsum,* 'I saw the Lord sitting upon a throne, high and lifted up' (Isaiah vi, 1).[44] His repeated explanations of the Trinity, with their emphasis on the oneness of God, may be reflected in the threefold inscriptions concerning the figure of Christ as well as in the painting of the Trinity, which, as I have suggested, was on the wall of the Bakers' Chapel behind the Altarpiece.

The threefold presence of Christ – as victim in the Lamb, resurrected and in glory in the principal figure, and as the source of all grace in the Sacrament – in special accordance with the Easter liturgy, is comparable with Rupert's identification of the Word of God with the Lamb, *Agnus, id est Verbum Dei.*[45] The eucharistic significance of the Lamb on the altar, of the angels bearing the instruments of the passion, and of those with censers, is evident. These symbols and the relationship of the Altarpiece to the daily mass may well in part have been inspired by Rupert's explanation of the liturgy in his *De divinis officiis.* Indeed, Rupert's comment on the Octave of Easter,[46] seen in the perspective of universal resurrection, is based on the Eight Beatitudes, which accords with a

92

permanent tradition linking the Adoration panel with the Beatitudes, and on the Epistle of Low Sunday, the Sunday after Easter (I John v, 5-10) concerning the Witness of the Spirit, the Water and the Blood, represented on the panel by the Dove, the fountain and the Lamb.

A closer look at the allegorical system concerning the Redemption built up by Rupert of Deutz, in particular as it is set out in his *De victoria Verbi Dei*, reveals many resemblances to the Altarpiece's iconography. A brief outline of these resemblances is all that can be given here: for more detailed information the reader is referred to Migne's *Patrologia Latina*, where the writings concerned are given in full.

In the preface to the *De victoria Verbi Dei* Rupert describes the Kingdom of God as a realm of peace, love and brotherhood, of devotion, truth, righteousness and gentleness such as finds expression in the mood of the Altar as a whole. The enemy of the Kingdom is the seven-headed dragon of the Apocalypse which the archangel Michael defeated.[47] Rupert returns to this dragon, which was seen as the Antichrist, again and again. It is shown in a carving representing St Michael's victory on the side of the Singers' lectern in the Altarpiece [48], rearing its head even in defeat in accordance with the text in Revelation (xiii, 14). That the dragon is depicted, not as a visionary reality but in the 'unreal' form of a sculpture in wood, is typical of the Van Eycks' realism, in which such creatures of the imagination had no place.

Rupert of Deutz explains that the struggle of the Archangel Michael with the dragon centres on Man in the person of Adam. Because of his victory the angels, wearing golden bands ornamented with precious stones (like the Van Eycks' Singers and Musicians [49]), *laudaverunt et jubilaverunt*, 'sang praises and rejoiced'.[48] Man, created in God's image, sinned out of pride, yet again and again God promised redemption *per crucem et sanguinem*

48. Detail of *The Singers* panel

49 (*opposite*). Slightly enlarged detail of *The Singers* panel

suum, 'By the cross and by His blood' [8].[49] Cain and Abel [50], above the figures of Adam and Eve, prefigure the Redemption. Rupert names Abel *principium electorum generationis*, 'the progenitor of the elect'.[50] Seen in this light, the presence of the panels with Adam and Eve and the story of Cain and Abel is in no way problematic; indeed they provide the key to the iconographic scheme.

If the Redemption is necessitated by the Fall of Man and prefigured by Cain and Abel, its starting-point is the conception of Christ in the Virgin Mary's womb, which was revealed to her in the Annunciation [51]. In the light of Rupert's commentaries on the

50. The *Cain slaying Abel* panel

51 (*opposite*). Detail of *The Virgin Annunciate* panel

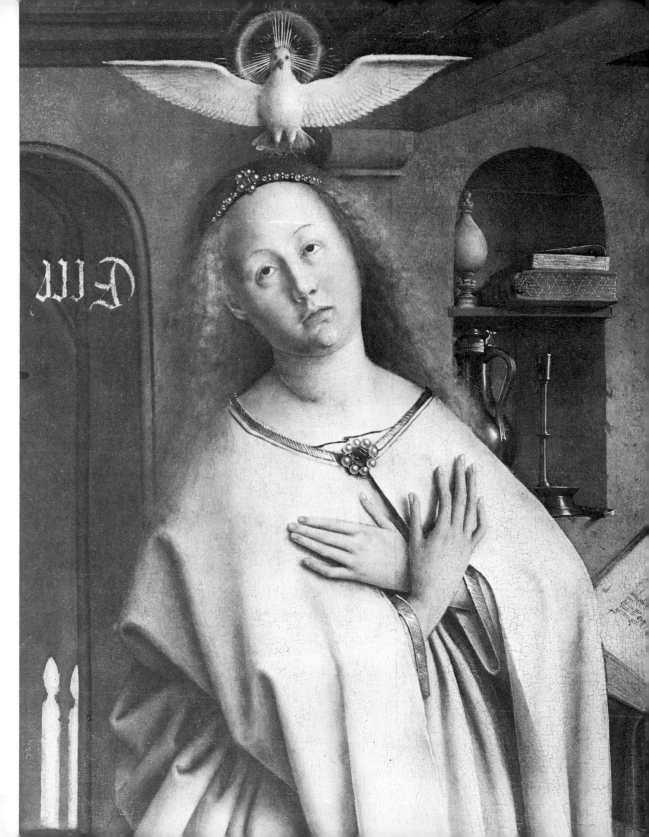

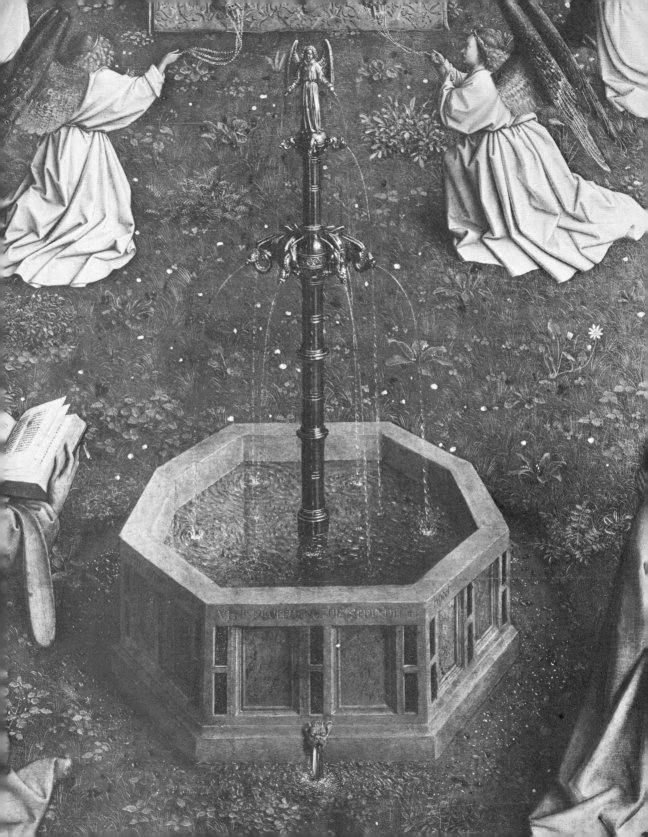

prophets Zechariah and Micah[51] and that on the Annunciation (in *De gloria et honore Filii Hominis*),[52] the paintings of the upper and middle zones of the closed Altarpiece [16], where Zechariah and Micah, with their books of prophecies prominently displayed, and the Annunciation itself are shown, take on a new significance and their relevance to the main theme, which has also been questioned, becomes evident.

The figures of the Virgin and St John the Baptist in the central triad of the open Altarpiece would also accord with the writings of Rupert of Deutz. In *De victoria Verbi Dei* the Virgin Mary is equated with the woman with the crown of twelve stars of the Apocalypse (Revelation xii, 1;[53] see also Rupert's commentary on the Song of Solomon.)[54] The momentous words with which the Baptist announced Christ on earth as the Redeemer, *Ecce Agnus Dei qui tollit peccata mundi* (the words written on the antependium of the altar in the Adoration panel and pronounced during the mass) are referred to in the same work.[55] In addition, Rupert of Deutz discusses Christ's descent into limbo for the redemption of the souls who waited there for His coming.[56] Not only was the 'hell' painted on the lost predella probably a representation of limbo; the group of figures from the Old Testament and antiquity [20, 21] in the left-hand foreground of the Adoration panel is also related to this theme.

The symbolism of the panel showing the Adoration of the Lamb itself embraces both the Redemption of mankind by Christ's sacrifice on the cross, which is re-enacted in the mass, and the grace which the Redemption bestows. In further passages which, we would suggest, are relevant to this scene, Rupert of Deutz discusses the patriarchs, prophets, judges and warriors of the Old Testament, and the Apostles, Evangelists, priests and teachers through whom 'all peoples, tribes and tongues' may serve God to all eternity. Rupert shows that these categories of the elect, with all the faithful, together make up the one and universal church.[57] The

52. Detail of
The Adoration of the Lamb panel

various categories of saints, which Honorius of Autun was later to incorporate in his sermon on All Saints, are listed more than once in Rupert's works.[58] In his commentary on the Sermon on the Mount he describes the Blessed of the Beatitudes in terms which remind one of these.[59] Rupert also devoted many pages to the Works and Gifts of the Holy Spirit, from whose aureole, in the Altarpiece, rays descend to the various groups of figures. These Works and Gifts are conferred through Baptism and the Eucharist. The shape of the Fountain of Life [52, 53] in the Adoration panel, reminiscent of the octagonal form traditional in fonts, was probably chosen to symbolize Baptism. Rupert repeatedly refers to the Fountain of Life, citing the words of Revelation which are summed up in the inscription on the fountain in the Altarpiece: 'And he shewed me a river of water of life, clear as crystal, proceeding out of the throne of God and of the Lamb' (Revelation xxii, 1).[60] Rupert links this text with the twelve Fruits of the Holy Spirit, which may perhaps explain the twelve jets of water which spout from the bronze column of the fountain in the Altarpiece.

Nearing the end of his *De victoria Verbi Dei* Rupert of Deutz exclaims: *Qualis triumphator, Deus Verbum, Deus et homo Jesus Christus in majestate sua sedebit*, 'What a triumpher, God the Word, Jesus Christ, God and Man; so shall He be seated in His majesty' [37]. He then cites Christ's invitation: 'Come, ye blessed of my Father, inherit the kingdom prepared for you from the foundation of the world' (Matthew xxv, 34).[61] The same sense of plenitude and triumph is manifest in the iconography of the Ghent Altarpiece, where it is expressed with all the solemnity and dignity of the Van Eycks' formal language. Again and again one is struck by Rupert's abundant and fertile imagery, which has an extraordinary power of giving visual and concrete form to abstract theological ideas. Even the summary given here should be enough to show that his writings are likely to have been an important source for the Altar's iconography. It seems clear that they influenced the form that the Altar-

piece took and that, directly or indirectly, the imagery of Rupert of Deutz was a source of inspiration to the artists in their magnificent attempt to express the Mystery of the Redemption of Man, in all its complexity, in visual terms.

The works of Rupert of Deutz must have been known to scholars in Ghent. The city had long-standing economic and other ties with the Maas area and the Rhineland, where Rupert lived and worked; indeed Hubert van Eyck's coming to Ghent may have been part of the age-old movement from east to west which had stimulated these connections. Ghent was, moreover, renowned for its many libraries; the founding of the scriptorium and library of the House of St Jerome by Johannes van Impe, Master of Arts and priest at St John's, in the very years in which the Altarpiece was painted, shows the importance which was attached to literary works at this time. The Ghent Altarpiece may perhaps be seen as reflecting the interest in Rupert of Deutz which was to lead to the printing of his works later in the fifteenth century. The use made of his writings in the treatise *Dye declaratie vander missen* (The Explanation of the Mass) by Ludolf Nicholas of Zwolle, which was published in 1529,[62] also testifies to his being well known. In contrast to other works on the mass dating from the same period which are of a more devotional nature, this allegorical interpretation corresponds with the iconography of the Altarpiece in many particulars. Though it is of later date, it may be cited here in brief as a proof of Rupert's influence and for the close parallels with the Altarpiece that it provides. It contains the following passages concerning the mass (texts which also occur in inscriptions on the Altarpiece are given here in italics):

'The mass was instituted . . . for the redemption of human nature which in *Adam* had gone astray . . . All the masses that the priests now celebrate have the same significance as that unique mass offered by Christ, the Supreme Priest . . . [The mass] is a fountain

that gushes forth, from which forever and without ceasing flow streams of living waters . . . a fountain into which are poured, and from which stream out before the eyes of men, the manifold benefits of Christ . . . The mass was instituted as the one everlasting sacrifice of the New Testament to replace the many sacrifices of the Old Testament . . . God promised Adam, Abraham and other prophets and kings that he would become man . . . [He did this] not immediately . . . but after many thousands of years and . . . not before the Blessed Virgin Mary answered the Angel Gabriel saying *"Behold the handmaid of the Lord, be it unto me according to thy word"* . . . Christ is *the Way, the Truth and the Life* . . . The altar, composed of many stones, signifies the Holy Church, which consists of many people of different nations, both Jews and heathens, gathered together. The epistle signifies the preaching of St John the Baptist . . . who pointed with his finger, saying *"Behold the Lamb of God"* . . . He who shall come there under the hands of the priest [i.e. in the Sacrament] is *God Almighty, King of Kings and Lord of Lords.* Every soul will then be commended [to God] so that His grace may be apportioned to each: each according to his estate. The Agnus Dei [of the mass] signifies the Atonement, and the Pax the way in which men are united with God in everlasting peace.'

53. Detail of 52

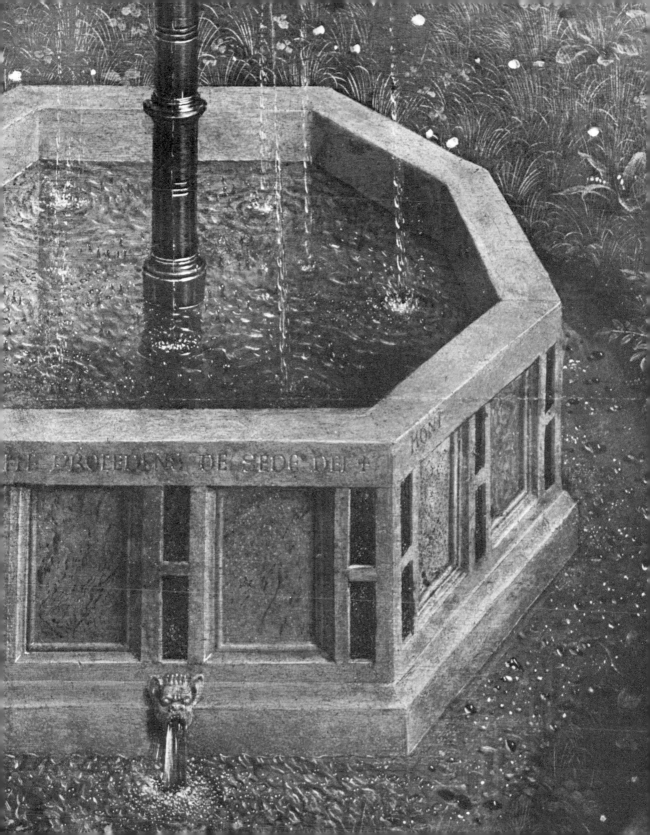

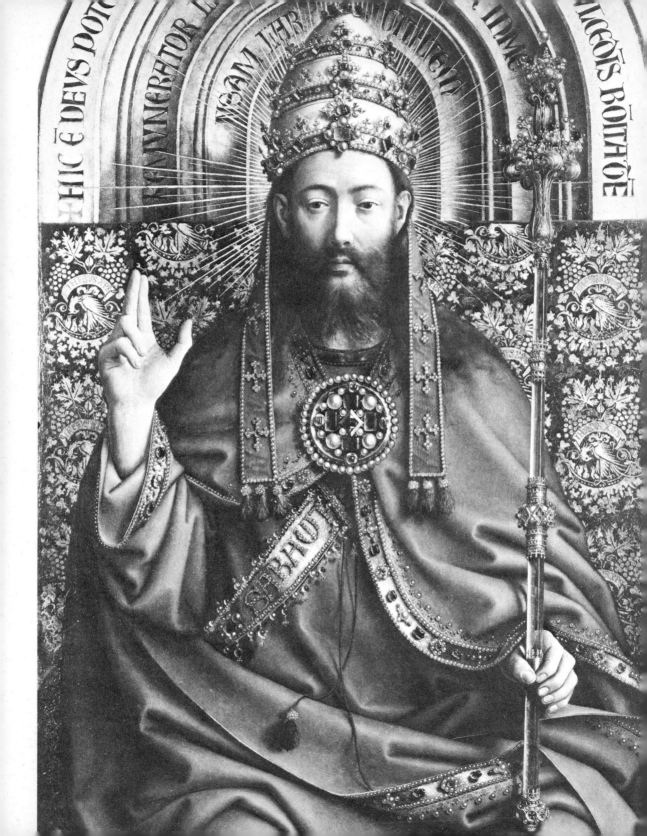

6. Formal Sources

54. Detail of the
Christ Enthroned panel

55. Detail of
The Adoration of the Lamb panel

The aims of the donors and the erudition of the author of the complex iconographic scheme must have made the task of composition a hard one. Yet, like the medieval theologian and writer, the medieval artist was able to draw on a rich heritage, consciously or unconsciously selecting material from a common store of motifs and meaningful compositional relationships.

The hieratic character of the Almighty [54], a symmetrical, flat and motionless figure shown from a strictly frontal viewpoint, without doubt echoes Early Christian and Byzantine traditions. Its ultimate source of inspiration must be the monumental figures of Christ in the mosaic decoration of many apses in churches in Venice, Ravenna and Rome, which the painter might have known through derivative works or at first hand; the records do not tell us whether the Van Eycks visited Italy, but the possibility that one, or even both of them, did so is by no means excluded. These monumental figures often appear in association with the symbolic Lamb of God, which is found in Christian art from very early times. In addition, the peacock-feather wings of one of the censing angels of the Adoration panel [55] may have been inspired by Early Christian mosaics.

Other features of the Altarpiece may have been inspired by the miniatures in illuminated manuscripts, in which Ghent was undoubtedly extremely rich. In miniatures of the Carolingian period, for example, there are numerous representations of the Adoration of the Lamb, the Fountain of Life, and Christ in Majesty, these subjects sometimes being linked. The designer may also have drawn inspiration from the representations in medieval miniatures of the Court of Heaven as described by St Augustine in his *De*

Civitate Dei. In particular the placing and pose of the Virgin in the central triad of the open Altarpiece is related to these scenes, in which she is shown seated at the right hand of the Trinity, usually at a slightly lower level. St John the Baptist, however, seldom appears in these miniatures at the Deity's left hand as a figure balancing that of the Virgin. The three great presiding figures in the central panels of the upper register also contain reminiscences of representations of the *Deesis* and the Last Judgement, though their tenor is of course entirely different. In the Altarpiece Christ does not judge; the Virgin and St John are not mediators. St John, indeed, is shown in glory rather than as a preacher of penitence [41]. Medieval representations of the Coronation of the Virgin perhaps present a closer parallel, for these too may include three main figures placed more or less in a row at the centre of an upper zone. The submissive attitude of the Van Eycks' Virgin, her head inclined as though she feels the weight of the crown which, here, she already wears, is reminiscent of such compositions. It is not surprising that De Beatis, Van Vaernewyck and Van Mander all associate this figure with the Coronation of the Virgin. De Beatis, for example, refers to *la Ascensione de la Madonna*, 'the Assumption of the Virgin', a term which clearly includes her Coronation in this case.

The Adoration of the Lamb is itself reminiscent of late medieval Italian representations of Paradise, with their hosts of figures, such as that by Nardo di Cione in Santa Maria Novella, Florence (*c.* 1354–7), and, in particular, that by Guariento in the Doge's Palace in Venice (1365–7), of which only a few fragments now survive. This work was the prototype for many altarpieces in which the Coronation of the Virgin was shown (e.g. that by Jacobello del Fiore [56] in the Accademia, Venice, of 1432 or 1438). The different registers of Italian trecento altarpieces, with their monumental figures in the upper zone and smaller figures (or scenes containing these), sometimes on a predella, below, may also be reflected in the arrangement of the Ghent Altarpiece. There seem to be further Italian reminiscences in the details of the Adoration panel, in the

56. *Paradise*, 1432 or 1438.
Jacobello del Fiore

figures, in the early renaissance basin of the Fountain of Life [52, 53], which was certainly inspired by Italian models, and in the southern vegetation, with its cypresses, palms, and bushy orange trees, whose presence need not necessarily be explained solely in terms of Jan van Eyck's journey to Spain and Portugal of 1429. The snowy mountain peaks in the panel showing the knights could embody memories of a journey through the Alps. The classical laurel

wreaths worn by Virgil [21] and the three standard-bearers [34] would also accord with an interest in Italy.

Late medieval sculpture has also been seen as a possible source for parts of the Altarpiece. Sculpture was often designed, as well as being coloured and gilded, by painters at this time; we know from documents relating to an altar made for Robrecht Poortier of Ghent, and from the city accounts of Bruges, that both Hubert and Jan van Eyck carried out work of this kind. The sculptures of Claus Sluter at Champmol may present a general parallel with parts of the Altar in their approach to the representation of solid form, but even in this case close stylistic parallels are not evident. A new sense of space and three-dimensional form was, moreover, beginning to be introduced into Flemish painting in works by the Master of Flemalle at about the time when the Ghent Altarpiece was painted.

The Adam and Eve of the Altar [57] have been compared by many writers with Masaccio's Adam and Eve [58] in the Brancacci Chapel in Santa Maria del Carmine, Florence (c. 1426–8). Here once again the question of a possible journey to Italy asserts itself. Some measure of artistic rivalry with Masaccio's for their time startlingly plastic figures shown in perspective in the Brancacci Chapel and in his other frescoes in Florence cannot be ruled out. The viewpoint from which Adam and Eve are shown, which is slightly below the lower edge of the panels concerned (as may be seen very clearly in the portrayal of Adam's feet) is comparable with the viewpoint of Masaccio's painting of the Trinity in Santa Maria Novella, Florence (c. 1425), where the Virgin and St John stand on a step slightly above the spectator's eye-level. The very recent improved application of the principles of linear perspective in Florence had enabled Masaccio to show his Trinity, in its setting, as though from this viewpoint. The choice for the Adam and Eve of a similar viewpoint, which up to this time was unknown in northern art, may very well have been inspired by Masaccio's work.

The parallel with Masaccio might be taken to imply that Jan van Eyck (the supposed author of the panels with Adam and Eve, as

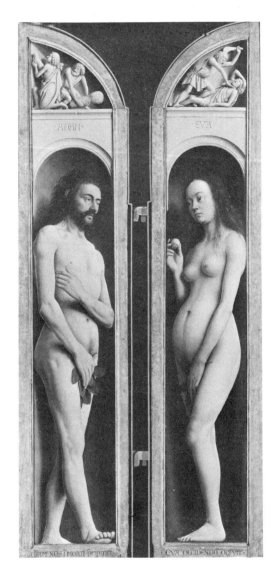

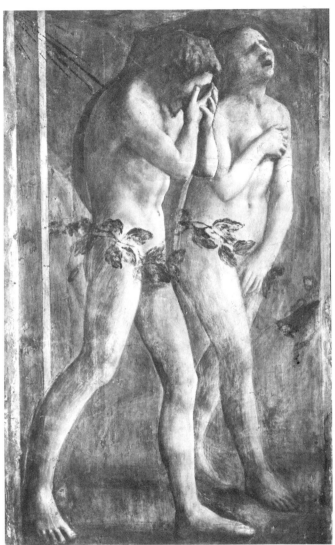

57. The *Adam* and *Eve* panels

58. *Adam and Eve, c.* 1426–8. Masaccio

59. *God the Father*, *c.* 1417. Donatello

will be shown) did in fact travel to Italy, known to be a tradition
from the writings of Marcus van Vaernewyck, and that he visited
Florence in the late 1420s. It is therefore perhaps relevant to note
a likeness in the Ghent Altar to another Florentine work of art
which was recent at the time, and of striking originality: the half-
length figure of God the Father carved in low relief in the tym-
panum above the niche on Or San Michele in which Donatello's
St George stood [59]. This figure, which can be attributed with
certainty to Donatello, is likely to have been carved about 1417.
Unlike the traditional figures in niches and tympana of medieval
art, which are confined within the architectural framework in which
they are shown, the halo of Donatello's God the Father overlaps
the architecture of the pediment so that he seems to lean forward
into the outside world. The drapery of his sleeve and the book

60. The *Prophet Zechariah* panel

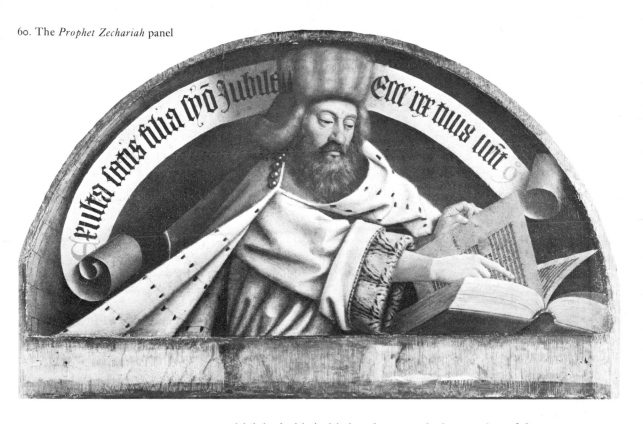

which he holds in his hand rest on the lower edge of the tympanum, enhancing this effect, and the head is shown in perspective as though inclined forward. The prophets shown half-length in niches above the outer Annunciation panels of the Ghent Altarpiece are brought into contact with the spectator by similar means. Zechariah [60], to the left, points to a book, seen from below, which overlaps the edge of his niche almost precariously; his head and his tall fur cap are seen in front of the edge of his niche, to which the scroll bearing his prophecy seems to be attached, and cast a shadow on the scroll. Micah [10] looks down out of his niche towards the Virgin directly below him with a tilt of the head comparable to that of Donatello's figure, leaning on the edge of his niche as he does so, and with a book beside him which, with its marker, also seems to project into the space of the Vijd chapel itself.

7. Style and Genesis

Clearly it took some years to execute the ambitious programme. The numerous repaints [27, 61], some of which are quite extensive, show that many changes were made while the work was in progress. These changes may result from new ideas occurring to the artist during the course of the work or from the correction of work done

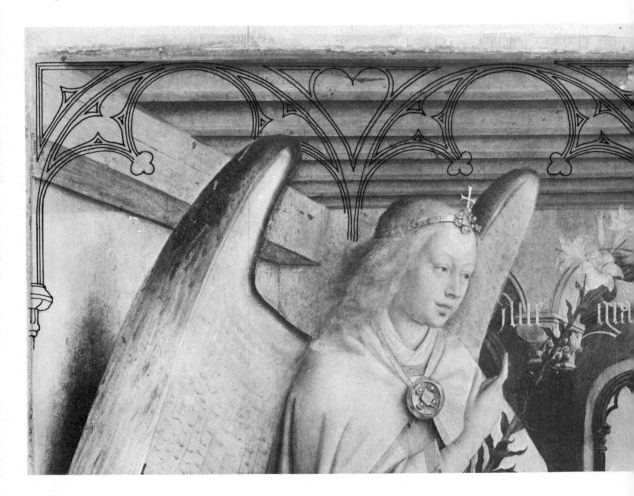

by assistants; they may also have been made by Jan van Eyck in parts begun or carried out by Hubert, or at the request of the donor or the author of the iconographic scheme. The composition is based nevertheless on a harmonious and satisfying geometric plan [62A, B] which embraces not only the parts of the Altarpiece which we see today but also those that are lost: the altar-table, the predella, the framework of the three registers, the intermediary register with the tabernacle, and the baldachin. This conjectural scheme is based on seven circles and the original decorative arcading of the closed Altarpiece, controlled by the symbolism of numbers.

61 (*opposite*). Detail of the *Archangel Gabriel* panel, infra-red photograph showing the over-painted arches and tracery (here strengthened with black)

62A (*right*). Study of the Altar's geometric scheme based on archaeological evidence, with plan of the eastern arcade of the chapel

62B (*far right*). Tentative reconstruction of the closed Altarpiece's conception

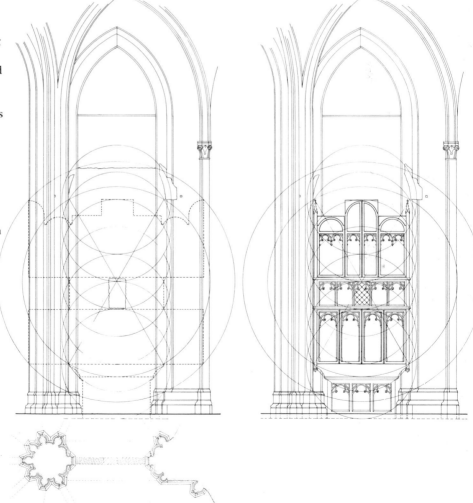

The modification of this scheme by the transformation of the six arcades of the upper register, with their shallow backgrounds, into the continuous illusionistic space of the room of the Annunciation, points to the intervention of a new, strong personality – to the intervention of Jan in the pre-existing work of Hubert.

The question of Hubert's and Jan's shares in the work was first raised by Waagen in the early nineteenth century. Yet it was not until the end of the century, and still more after the paintings of Adam and Eve had been exhibited at Bruges in 1902, that attempts were made to distinguish the work of the two 'hands' by means of stylistic criticism. Diametrically opposite results were sometimes arrived at by the early writers, but it must be remembered that stylistic criticism was new and that wrong conclusions were often drawn because the circumstances in which the works concerned were created were little known. Moreover, the common features of the style of a given place and period were not always distinguished from the characteristics of the individual artists' styles. The study of the Ghent Altarpiece was particularly difficult, for at the beginning of the present century its panels were still dispersed in Ghent, Brussels and Berlin. Even after they had been reunited in 1920 the theories advanced earlier died hard; writers who compiled their works from the findings of others repeated them, and some scholars were loth to change their views. The confusion was increased by speculation about the authorship of the miniatures often attributed to the Van Eycks in the Turin–Milan Book of Hours. It is hardly surprising that, faced with so much controversy, E. Renders went so far as to deny both the authenticity of the quatrain on the Altarpiece and Hubert's very existence. Even with the help of modern techniques of examination the problems of authorship have not been solved. This may perhaps be due to inadequate interpretation of the results rather than to deficiencies in the techniques themselves.

To distinguish between the work of the two brothers, who had probably had the same training, is of necessity difficult. We have to look for differences of degree rather than sharp contrasts. It must

also be remembered that Jan had to take over a composition which was at various stages of completion. Some parts may have been finished, some merely laid in. Some were perhaps not yet begun, though a scheme must already have been drawn up for the whole work. Jan's final harmonization of the various parts may have called for a number of alterations. It would thus be prudent to look for differences of approach and conception in the various panels of the Altar, examining them in relation to what we know of Jan's authenticated independent works. No authenticated works by Hubert which might serve as a point of comparison are known.

One of the principal characteristics of Jan van Eyck's independent works, his portraits of a single sitter excepted, is the convincing representation of the space in which his figures are set, which is seen from a central viewpoint and arranged symmetrically. Where the painting consists of more than one panel a single scene is represented throughout the work. His interiors are related to the picture's surface in one of two ways: either the surface of the panel takes the place, as it were, of one wall of the room or church interior shown (as in the small triptych of *The Madonna and Child with Saints* of 1437, Gemäldegalerie, Dresden), or it seems to cut across the space represented, giving the feeling that the spectator too is in the building shown (as in *The Wedding Portrait of Giovanni Arnolfini* [66], *The Madonna of Van der Paele*, 1436 (Groeninge Museum, Bruges), *The Lucca Madonna* [74], and *The Madonna of Chancellor Rolin*, Louvre [64]). The spectator may be brought into relationship with the scene with great subtlety, as in *The Madonna of the Fountain* (1439, Museum voor Schone Kunsten, Antwerp), where the fountain's basin seems to project towards us out of the painting, the slim pillar that supports the far wider basin being placed close beside the painting's lower edge. Though the perspective is not always correct (there may be more than one vanishing point) Jan van Eyck represents objects and scenes in depth much more clearly than was usual in the northern art of his time; one would, indeed, be able to draw plans and sections of his architecture with

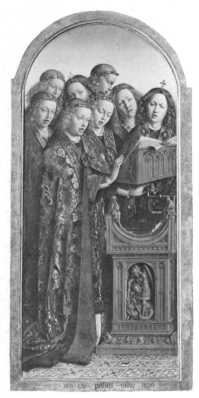 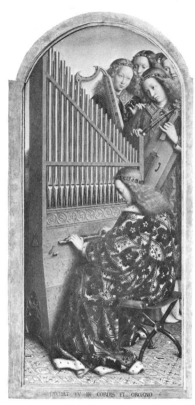

63A, B. *The Singers* panel and
The Musicians panel

some accuracy. In his convincing settings, whose relationship to
the spectator is so clearly defined, his equally concrete figures,
generally few and portrayed on a relatively large scale in relation to
their setting, are painted in such a way that each appears as a free-
standing mass described by means of a consistent use of light and
shadow.

The panels of the inside of the Ghent Altarpiece, except those
showing Adam and Eve and the story of Cain and Abel, are designed
differently. The composition of the central triad of the upper
register, of the panels with the Singers and Musicians (these pend-
ants being considered together [63A, B]) and of the paintings of the
lower register, is in each case to a large extent symmetrical and has a
central axis, yet it is more closely tied to the two dimensions of the

64. *The Madonna of Chancellor Rolin.*
Jan van Eyck

picture plane. In the lower register, for example, the horizon is higher than it is in Jan van Eyck's independent works in which landscapes are shown (among them *The Madonna of Chancellor Rolin* [64] and the *St Barbara* of 1437, (in the Museum voor Schone Kunsten, Antwerp), so that the recession into the distance is more gentle. In addition, the bushes, hills and other features, especially in the central panel, form coulisses which, though they suggest depth, preclude a clear definition of the transitions, from the foreground into the distance, of the landscape as a whole. Here too the landscapes shown in Jan's independent works are different; he describes their topography with exceptional clarity. The perspective systems used in the altar and the fountain have, moreover, viewpoints at levels differing more widely than those implied in Jan's

independent works, and in the five central panels of the upper register the perspective of the floors, which are seen from above, is not answered by the construction of an architectonic space. Only the sky is seen behind the Singers and Musicians; the upper parts of the three central panels, where now a neutral blue background is shown, were probably hidden behind the original frame of the Altarpiece.

In marked contrast to this, the form of the niches in the panels with Adam and Eve [57] is so clearly defined that they could be realized in three dimensions. They are shown from the viewpoint of the spectator in the Vijd chapel, who looks up at them, so that their floors, unlike those in the remaining upper panels of the open Altarpiece, cannot be seen. Adam and Eve stand freely in their narrow, shallow, but genuinely concave niches. They too are shown from below; though they face towards Christ we see them largely in three-quarter view, their further shoulders receding realistically and hardly visible. Their nearer shoulders, elbows and thighs appear to project out of the confined space of the niches and thus, like the basin of the fountain in Jan van Eyck's *Madonna of the Fountain*, beyond the picture plane. Adam's foot also projects, as does that of Cain in the seemingly sculptured scene above him. These features reveal a desire to experiment which is characteristic of Jan van Eyck's independent works. Though the pursuit of 'originality' was unknown at this date, it seems that the panels showing Adam and Eve have been tactfully, yet clearly, dissociated from the remaining panels of the open Altarpiece.

The way in which the figures in the other paintings of the open Altar are portrayed is different. In the Adoration of the Lamb panel the groups representing the various categories of the Blessed are distributed in the fields of paradise somewhat flatly and the groups themselves, which are closely-packed, are also somewhat flat. The figures in the side panels of the lower register, though they are shown moving forward and in the left-hand panels are less numerous,

are also arranged with a certain flatness which relates them to the picture plane. The Singers and Musicians in the top register are disposed in a similar way. The great figures of Christ, the Virgin and St John the Baptist are spread over the greater part of the panels which they occupy and their draperies are treated in terms of flat pattern rather than three-dimensional form. Similarly, throughout all these parts of the Altarpiece there is a tendency, where figures are represented in three-quarter view, to place the shoulders as nearly as possible parallel to the picture plane; the effect of depth is thus minimized. The contrast with the boldly-placed figures of Adam and Eve, and with the solid beings portrayed in Jan's independent works, is evident. We may conclude that Jan van Eyck, though he may have contributed to the execution of these panels of the open Altarpiece, was not responsible for their general design, which in each case must be by Hubert or at least conceived in accordance with his scheme. Jan must, however, have been the sole author of the panels showing Adam and Eve.

Laboratory examination has shown that the room in which the Annunciation is set was not part of the original scheme;[63] it is painted over arches with tracery similar to those in the lower register [61]. This explains the discrepancy between the way in which the architecture of the room is represented and the handling of the figures. The scale of the figures [65] does not harmonize with that of the room, in which they would not be able to stand upright, and their garments, like those of the enthroned figures of the open Altar, are conceived in terms of flat surface pattern rather than three-dimensional form. In all probability these figures, together with the overpainted arches, formed part of Hubert's original design, in which they are likely to have been shown as though carved in relief, and in shallow niches. In the Virgin's room the frames of the panels on which the scene is painted, as though lit by daylight from the windows of the Vijd chapel itself, cast shadows on the tiled floor. The shape of the objects in niches in the far wall seems to have been

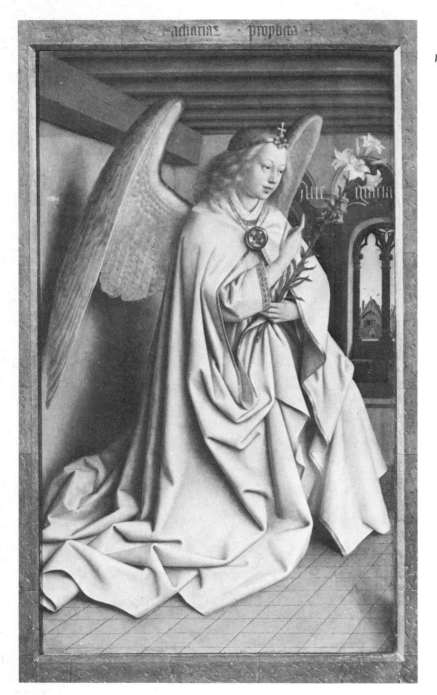

65. *The Archangel Gabriel* panel

66 (*opposite*).
Wedding Portrait of Giovanni Arnolfini,
1434. Jan van Eyck

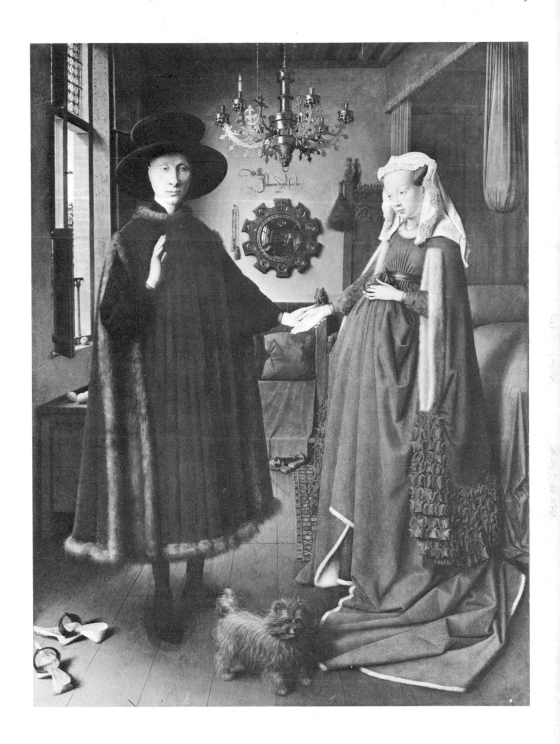

67. Detail of
The Adoration of the Lamb panel

68. Detail of
one of the *Annunciation* panels

determined by a delight in solid, geometrical form [51,68]. The topo-
graphy of the town seen through the windows [72] is defined meticu-
lously. There can be no doubt that this setting is the work of Jan.

Varying degrees of intervention by Jan may be detected in the
remaining panels of the closed Altarpiece. In the niches shown in the
upper register, as well as in the Prophets who, with their books,
seem to project towards the spectator, we may recognize Jan's hand.
Though the Sibyls are more conservative in their design it is likely
that here too Jan had a share in the work, even if he was not the

author of these figures. The paintings in the lower register, with its pattern of gothic arches and its figures in which, as in the Annunciation, the surface pattern of the drapery is emphasized, were clearly designed by Hubert. Yet it is likely that here too Jan intervened to some extent, in particular in the donors' portraits.

By eliminating the parts of the Altarpiece clearly attributable to Jan we have gained some impression of the main characteristics of Hubert's style. It seems that, in his monumental compositions, he tends to adhere to the two dimensions of the picture plane [67] and is to a large extent bound by tradition. Jan, on the other hand, strives to represent both space and solid form [68, 70], reflecting the means of expression of renaissance art.

69 (*below*). Detail of *The Virgin Enthroned* panel

70 (*right*). Detail of the *Adam* panel

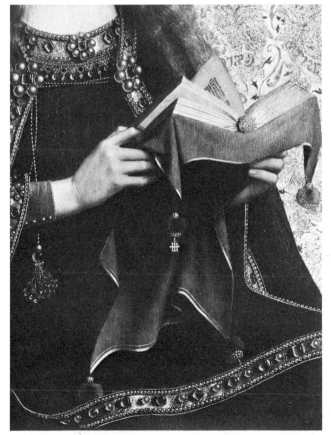

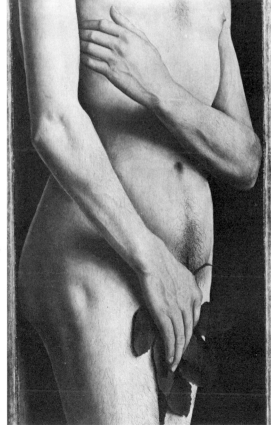

122

Is it possible to distinguish separate styles in other aspects of
the representation of the various figures and objects shown? Both
artists, helped by improved techniques resulting from the develop-
ment of oil painting, suggest the nature and texture of each material
that they represent, revealing their deep and all-embracing enjoy-
ment in the appearance of things. Yet in Jan's independent works
reality is represented with a striking directness: what is shown
appears to have been individually portrayed. In those parts of the
Altarpiece whose design suggests that they are largely or wholly by
Hubert the reality of the figures, setting and objects shown appears
to have been represented in some measure at second hand. Adam
and Eve were clearly drawn from life, and by Jan, the uncompromis-
ing portrait painter, whose concern is to represent the individual

71. Detail of *The Adoration
of the Lamb* panel

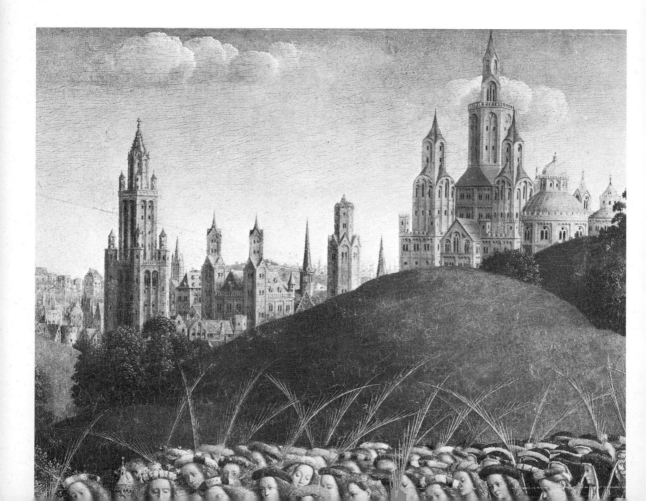

as he appears at a given time and place. As in Jan's portraits [14], the persons portrayed seem alive and active and are shown as though they focus their attention on a given object, in this case the Deity. The figures in the parts of the Altarpiece attributable to Hubert, on the other hand, are pensive and contemplative. Their gaze is fixed on eternity. Moreover types, expressions, poses and gestures are repeated in his groups of figures with only slight variations, which suggests that Hubert often worked from sketchbooks rather than directly from life. A similar difference may be seen in the landscapes in the Ghent Altarpiece. Whereas the view seen through the windows in the Annunciation panels seems to be a glimpse of the real world [72], the landscape of the lower register of the inside of the Altar has been assembled in a somewhat artificial way [71]. The

72. Detail of one of the *Annunciation* panels

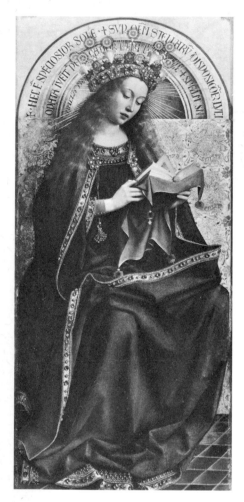

73. *The Virgin Enthroned* panel 74. *The Lucca Madonna*. Jan van Eyck

flowers in the fields of heaven resemble a herbarium, whereas in the garden of *The Madonna of Chancellor Rolin* [64] they appear in their real environment.

It may also be asked whether differences of character are reflected in the Altarpiece. In the Virgin enthroned [73] a certain timidity can be detected; Jan's enthroned Madonnas [74] are painted with greater self-assurance. The inner life of many figures in the Altarpiece, the way in which they are sunk in thought or filled with emotion, is expressed by a slight inclination of the head which may perhaps reflect a certain introversion in the character of the artist himself. Adam and Eve, so clearly the counterparts of the figures in Jan's Rolin and Van der Paele altarpieces, are more positive; they are confident beings seen in the clear light of a newly-discovered earthly world.

A more detailed study of the repaints than has so far been made would without doubt enable the shares and characteristics of the two brothers to be distinguished more exactly than is possible at present. Yet it is already evident that Jan's contribution to the Altarpiece, both in the parts which he designed and where he completed what was already present in Hubert's scheme, tends towards a clearer expression of space and plasticity, towards more outspoken effects of light and shadow, and towards a bolder use of perspective.

When the Ghent Altarpiece is considered in relation to the environment in which it came into being, and as an organic whole, it is clear that this unique and splendid work of art resulted from the combination of a number of factors: the pious intentions and the wealth of the donors, the knowledge and inspiration of the scholar who drew up the iconographic scheme, and the vision, creative power, and skill of the two artists. Though its basic theme is universal and is as old as the Christian faith itself, the form that the Altarpiece took depended on both the circumstances and the artistic developments of a given time and place. It is thus a document of the aspirations and achievements of fifteenth-century Netherlandish art.

8. Later History and Influence

Each generation looks at a work of art from a different viewpoint, being influenced by the spirit and events of its own time; even the treatment that works of art receive is influenced by such changes of outlook. Much could be written about the history of the Ghent Altarpiece which would illustrate this theme, but a brief chronological survey of events and opinions is all that can be given here. The stimulating effect of the Altarpiece on the new form of art that was coming into being in the Netherlands in the fifteenth century must also be mentioned. Elements related to the Altarpiece are already discernible in a number of contemporary miniatures, such as those in the Book of Hours made for the Ghent patrician Daniel Rijm, who died in 1431 (Walters Art Gallery, Baltimore), and some of those which have wrongly been attributed to the Van Eycks in the Turin–Milan Book of Hours. In their type, and in the convincing way in which their three-dimensional form is portrayed, the figures carved on the consoles supporting the vaulting of the sacristy of St Bavo's, which must be close to the Altarpiece in date, are reminiscent of the prophets of the upper panels. Because so many works of art were destroyed during the Reformation a true assessment of the impact of the Altar cannot be made, but its influence must have been widespread. It is likely that it was studied by Joos van Wassenhove and Hugo van der Goes, and its influence is certainly present in the work of Petrus Christus, the Master of the Grimacing St John, the Master of the Aix Annunciation (Bartholomew or Clement van Eyck?), Hans Memling, Gerard David, Jan Gossaert, Quentin Metsys and many lesser masters.

1445. The seventh chapter of the Order of the Golden Fleece was held in the choir of St John's Church. Alfonso V of Aragon was

admitted to the order at this chapter. In the same year his court painter Luis Dalmau, who had been in Flanders in 1431, completed his Retablo de los Concelleres (Museo de Arte de Cataluña, Barcelona); he was much influenced by the Van Eycks and borrowed motifs from their panel showing the Musicians. Many features in the vestments of the Order of the Golden Fleece (Kunsthistorisches Museum, Vienna) were clearly inspired by the Altarpiece. The date of the design of these vestments is uncertain.

1458. 23 April. On the occasion of the triumphal entry of Philip the Good into Ghent following the city's revolt and its defeat at Gavere in 1453, a *toog*, or *tableau vivant*, entitled *Chorus beatorum in sacrificium Agni Pascalis* (The Choir of the Blessed in Celebration of the Sacrifice of the Pascal Lamb), was presented on the open space known as De Poel by the Ghent Chambers of Rhetoric. The *tableau* corresponded closely with the panels of the open Ghent Altar except that Adam and Eve were not shown. It was perhaps connected in some way with the anonymous undated Flemish altarpiece representing the Fountain of Life [75] in the Prado, Madrid, whose composition is divided into three distinct zones, as was that of the *tableau*.

1459. 5 November. Louis, Dauphin of France (later Louis XI) stayed in the house in Ghent formerly occupied by Joos Vijd, as the guest of Vijd's nephew, Nikolaas Triest. We may assume that he was shown the Altarpiece.

1475. 19 May. Elisabeth Borluut's heirs granted the St Agnes's Chamber of Rhetoric permission to use their chapel in the crypt of St John's Church. This is mentioned in a document of 1478–9 as being 'under' Joos Vijd's chapel. The clear implication that the upper chapel was regarded as that of Vijd precludes the possibility that the Ghent Altarpiece was at first set up in the crypt as some authors have supposed. This is borne out by the relative heights of the crypt and the Altarpiece.

c. **1480.** A free version of the Adoration panel was given in a miniature now in the Instituto de Valencia de Don Juan, Madrid.

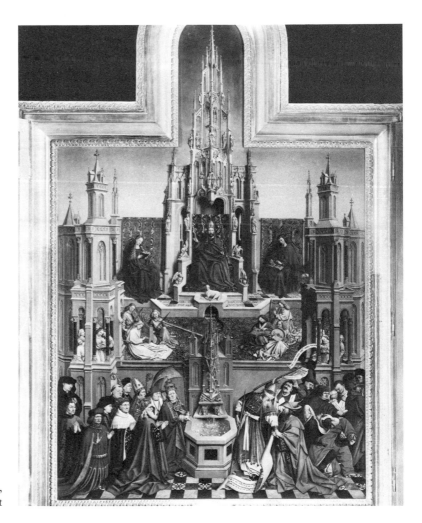

75. *The Fountain of Life*,
anonymous Flemish artist

1495. 26 or 27 March. The humanist Hieronymus Münzer of Nuremberg saw the Altar; he described it in notes made on his travels.

1517. 1 August. Cardinal Louis of Aragon visited the Altar. It was described by his secretary Antonio de Beatis.

1521. 10 April. Albrecht Dürer saw the Altar. He recorded his impressions briefly in his journal.

1530–1. Money given to St John's Church by visitors to whom the Altar was shown was mentioned for the first time in the surviving church records.

1532. The first centenary of the completion of the Altarpiece. It must have been at about this time that Hubert's grave was opened and one of the bones of his right arm, sheathed in iron, set up in the churchyard of St John's. The bone, known to Marcus van Vaernewyck for many years, had disappeared before he wrote his *Spieghel der Nederlandscher Audtheyt* (Mirror of Netherlandish Antiquity) in 1561–5. Probably wrongly, Van Vaernewyck associates the opening of the grave with the rebuilding of the nave of St John's Church, which began in 1533.

1540. On the orders of the Emperor Charles V St John's Church was taken over by the Chapter of St Bavo's Abbey. The parish's traditions were weakened as a result. The church was dedicated to St Bavo from this time onwards.

1546. 7 July. Captain Vincenzo Castrucci of Lucca visited the Altar; he recorded this in notes made on his travels.

Before 1550. The Altarpiece was clumsily cleaned. Van Vaernewyck, who provides this information, states that the 'hell' painted on the predella was lost as a result.

1550. 15 September. Lancelot Blondeel of Bruges and Jan Scorel of Utrecht began to 'wash' the Altarpiece. Van Vaernewyck tells us that they performed their task 'with such love that they kissed that skilful work of art in many places'.

1555. Joos Borluut recorded in his collection of memorial inscriptions that 'in the first chapel adjoining the steps' in the ambulatory of St John's Church, 'where the painting of Adam and Eve stands, all the windows bear the coats of arms of Joos Vijd and Mistress Elisabeth Borluut who gave the said painting to the church'.

1557–9. Philip II had a copy of the Altarpiece made by Michael Coxie.

1559. Lucas de Heere wrote an ode which was placed in the Vijd chapel on the occasion of the twenty-third Chapter of the Order of the Golden Fleece (23–5 July).

1559–61. St Bavo's became a cathedral on the creation of the Diocese of Ghent.

1564. A memorandum was drawn up to set the nature of the Vijd foundation on record.

1566. 19 August. The panels of the Altarpiece were hidden for safety in the tower of St Bavo's.

1566–8. Van Vaernewyck wrote his eye-witness account of the troubles of the time, in which he tells how the Altarpiece was hoisted into the tower in parts, which saved it from the 'filthy swines' hands of the iconoclasts.

Before 24 June 1569. The panels were returned to their original position.

1576–7. A watch was set in St Bavo's to guard the Altar.

1578. The Calvinists removed the panels of the Altar to the Town Hall of Ghent, meaning to offer them to the Prince of Orange 'for presentation to the Queen of England' (Elizabeth I), whose agent, William Davison, came to Ghent in 1579. The plan was opposed by Joos Triest, a descendant of Joos Vijd's sister. The brass plate bearing Hubert van Eyck's epitaph was probably stolen from his gravestone at about this time.

1587–8. The re-installation of the Altarpiece after the Wars of Religion involved some reorganization of the site. The new wooden railings set up on a brick foundation were probably placed further south, thus reducing the width of the chapel. The new brick altar was built about 87 cm. to the south of its original position. The Altarpiece was put on a new predella painted by J. Cools, and probably in a renaissance aedicular frame, the original framework being certainly damaged and lost. The upper register was lowered, the tabernacle being now out of use. The original frames of the wing panels were preserved and are still in use.

1588. 13 January. The altar of the Vijd chapel was reconsecrated.

1592–7. The church records show that during this period the Altarpiece was opened only four times a year.

1596. The triptych by Lucas Horenbout representing the Fountain of Life (Petit Béguinage, Ghent) was to some extent inspired by the Ghent Altarpiece.

c. **1600.** Christoffel van Huerne recorded the oldest known transcription of the Altar's dedicatory inscription in his collection of epitaphs (present whereabouts unknown).

1612. The painter Novelliers was commissioned to restore the Altarpiece.

1625. Antoon Triest, Bishop of Ghent (a descendant of Joos Vijd's sister), asked permission to have the Altarpiece copied.

1632. Bicentenary of the completion of the Altarpiece. At about this date the Vijd chapel was provided with the present railings of marble and brass, which were commissioned by the Triest and Borluut families and bear their coats of arms. A family tree drawn up in 1628 (known from a copy, Oudheidkundige Kring, Sint-Niklaas Waas) may be connected with this. It is said that the date 1432 was carved on the railings in 1639. This may have been on the chapel's gates, which were renewed in the eighteenth century.

1662–3. The panels of the Altarpiece were cleaned by A. van den Heuvel and were mounted in a baroque aedicular frame.

1633. The adjoining chapel (the Bakers' Chapel) was reorganized on behalf of Bishop A. Triest. The opening of the tabernacle in the wall between this chapel and the Vijd Chapel disappeared under a new marble facing. A painting by G. de Crayer filled the upper part of the arcade.

1731. The Altarpiece was cleaned by A. Forthuyn (Fontain).

1732. Tricentenary.

1742. The cathedral's precentor, Canon F. de Brunswijck-Luneburg, whose grandmother was a Borluut, was appointed chaplain of the Vijd foundation. The number of masses celebrated in the Vijd chapel had dropped to three a fortnight by this time.

1745-58. Two tombs were set up in the chapel: that of Mgr de Smet against the west wall in 1745 (removed at the beginning of the nineteenth century) and that of Canon de Brunswijck-Luneburg against the south-east wall in 1758. Presumably it was also at this period that Hubert van Eyck's gravestone was removed from the chapel; it was incorporated in the porch added to the north transept in 1759. It was recovered during the restoration of the cathedral in 1890-92 and is now in the Museum voor Stenen Voorwerpen (at the time of writing housed in St Bavo's Abbey, Ghent).

1769. J. B. Descamps visited the Vijd chapel. In accordance with the taste and theories of his time he commented that the only merit of the Altarpiece was that it was, he thought, the first picture to have been painted in oil.

1772. Canon A. Hellin described the Altarpiece.

1781. The Emperor Joseph II visited the Altarpiece. Sir Joshua Reynolds visited it and recorded his impressions in the same year.

1790. G. Forster visited and described the Altarpiece.

1794. The four central panels of the open Altarpiece were removed to Paris (where Ingres, whose Jupiter is in part derived from the Van Eycks' representation of Christ, must have seen them). The wings were hidden in Ghent.

1815. September to December. The panels taken to Paris were returned. They were officially handed over to the Ghent authorities on 10 May 1816 and were put back in position soon afterwards, though without the side panels, which were overlooked.

1816. 18 December. In the absence of the Bishop, Canon le Sure sold all the panels of the wings of the altarpiece except those showing Adam and Eve to the art dealer L. J. Nieuwenhuys. They were acquired in 1817 by the collector E. Solly and in 1821 by the King of Prussia, with whose collection they later came into the possession of the Kaiser Friedrich Museum, Berlin.

1816-17. The sale of the panels caused much agitation in Ghent. This stimulated fresh interest in the Altarpiece. (N. Cornelissen, 1817; P. F. de Goesin, 1819; L. de Bast, 1823.)

1822. The roof of St Bavo's caught fire. The four panels remaining in the chapel were saved, though damaged. They were restored by Lorent in 1825–8. Many reports on the Altarpiece's condition were drawn up during the nineteenth century. A further restoration was carried out by Donselaar in 1858–9.

1823. The quatrain concerning the Altar's dedication was discovered on the frames of the panels in Berlin.

1829. P. F. de Noter painted a historical evocation of the Vijd Chapel [76].

76. The Vijd Chapel, 1829. P. F. De Noter

1832. Quatercentenary.

1835. Mgr van de Velde refused a request that the panels showing Adam and Ave should be sold to the Belgian State.

1842. A neo-Gothic baldachin, probably inspired by the baldachin above the Altarpiece, was erected over the Goethals monument in St Bavo.

1861. The Adam and Eve panels were given to the Belgian State in exchange for copies of the wing panels, and were exhibited in the Musée des Beaux-Arts, Brussels.

1862. The panels in Berlin were photographed for the first time.

1869. The panels in Ghent were photographed.

1885-7. While the choir of St Bavo was being restored, the plaster was removed from the walls of the Vijd Chapel, the baldachin was removed and part of the profile to the left of the arcade was restored.

1894. The six wing panels in Berlin were sawn through to enable the inner and outer paintings to be displayed together, the frames being sawn through at the same time. The iron hinges were removed for this purpose.

1902. The Adam and Eve panels were exhibited in Bruges.

1914-18. The four central panels of the Altarpiece were hidden for safety in Ghent.

1920. In accordance with the conditions of the Treaty of Versailles the wing panels that were in Berlin were returned. The polyptych was exhibited in its entirety in Brussels. On 29 September it was shown in Ghent; on 6 November it was restored to its place in the Vijd chapel, the central panels being probably moved forward about 40 cm. (the thickness of the baroque columns of the aedicular frame).

1923. The Adam and Eve panels were exhibited in Paris.

1927. The first X-ray examination of the Altarpiece was carried out by experts from the Fogg Art Museum, Cambridge, Mass.

1932. A ceremony was held to mark the Altar's quincentenary.

1933. E. Renders launched his theory that the quatrain on the Altarpiece is a forgery.

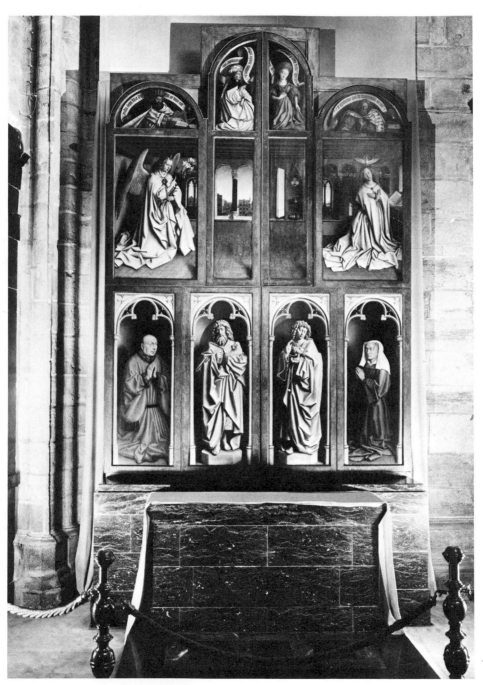

77. *The Ghent Altarpiece*
in situ

1934. 10-11 April. The panels showing the Just Judges and St John the Baptist were stolen. The St John the Baptist was later recovered but the panel with the Just Judges has never been traced. A replica by J. van der Veken takes its place.

1935-6. The portraits of the donors were exhibited in Paris.

1940-4. In 1940 the Altarpiece was removed to Pau. In 1942 it was taken to Neuschwanstein and in 1944 to Alt-Aussee. During this period E. Bontinck made a laboratory examination of the wing-frames, which had remained in Ghent.

1945. The Altarpiece was recovered by the American Forces and taken via Munich to Brussels, where it was exhibited, and was examined in the Laboratory of the Royal Museums for Art and History. It was returned to Ghent on 30 October, and surrounded by draperies to conceal the baroque aedicular frame.

1946. The Adam and Eve panels were exhibited in Amsterdam and Rotterdam.

1950-51. The Altarpiece was cleaned and restored in the Central Laboratory of the Belgian Museums (now Royal Institute for Art Patrimony) and was exhibited in Brussels. The baroque aedicular frame, and the brick altar, in which the deed of reconsecration of 1588 was found, were removed from the Vijd chapel. A lower marble altar was placed about 25 cm. to the north (i.e. to the spectator's left) in order to divide the space symmetrically and to make it possible for the wings to be opened equally on both sides (the space to the south having been reduced in 1758). The wall behind the Altar was lowered and De Crayer's painting was removed from the other side of it. All traces of the tabernacle and the baldachin were obliterated, apart from two iron clamps. The polyptych was put in a bronze frame, the wing panels together forming single shutters, moving like those of a triptych, and set above the new altar on 19 November 1951.

Notes

1. *Dürer, Schriftlicher Nachlass,* ed. Hans Rupprich, Berlin, 1956-9, vol I, p. 168. The translation is that given by William Martin Conway, *Literary Remains of Albrecht Dürer,* Cambridge, 1889, p. 117.

2. J. Reynolds, *Works,* 1797, II, p. 5.

3. See J. B. Descamps, *Voyage pittoresque de la Flandre et du Brabant, avec des réflections relativement aux Arts,* Paris, 1769, p. 220.

4. For the history of St John's and St Bavo's see E. A. Hellin, *Histoire chronologique des évêques et du chapître exemt de l'église cathédrale de S. Bavon à Gand,* Ghent, 1772, and *Supplément,* 1777; Kervyn de Volkaersbeke, *Les églises de Gand,* Ghent, 1857-8; F. De Smidt, *De kathedraal te Gent, archeologische studie* (Koninklijke Vlaamse Academie voor Wetenschappen, Letteren en Schone Kunsten van België, Klasse Schone Kunsten, Verhandeling XVII), Brussels, 1962; E. Dhanens, *Sint-Baafskathedraal, Gent* (Inventaris van het Kunstpatrimonium van Oost-Vlaanderen, V), Ghent, 1965.

5. For Van Impe and Roebosch see E. Dhanens, 'Le Scriptorium des Hiéronymites a Gand', *Scriptorium,* XXIII, 1969, pp. 361-79.

6. Ghent City Archives, MS. *Jaerregistre,* 1434-5, f. 149 v.; first published by V. van der Haeghen, 'Autour des Van Eyck, Cartulaire', *Handelingen der Maatschappij van Geschied- en Oudheidkunde te Gent,* XV, 1914, pp. 51-55. E. Dhanens, *Het retabel van het Lam Gods in de Sint-Baafskathedraal te Gent* (Inventaris van het Kunstpatrimonium van Oost-Vlaanderen, VI), Ghent, 1965, pp. 89-93.

7. *Messager des sciences historiques, ou archives des arts et de la bibliographie de Belgique,* I, 1823, p. 263.

8. ibid., II, 1824, p. 225.

9. E. Renders, *Hubert van Eyck, personnage de légende,* Paris and Brussels, 1933. F. Dülberg, *Niederländische Malerei der Spätgotik und Renaissance* (Handbuch der Kunstwissenschaft), Wildpark-Potsdam, 1929, p. 8, had raised the question of its being a forgery earlier. The theory was taken up by M. J. Friedländer, *Die Altniederländische Malerei,* XIV, 1937, supplement to the Van Eycks, and by others. It has been convincingly refuted by, among others, J. Duverger, *Het grafschrift van Hubrecht van Eyck en het quatrain van het Gentsche Lam Godsretabel* [etc.] (Koninklijke Vlaamse Academie voor Wetenschappen, Letteren en Schone Kunsten van België, Klasse Schone Kunsten, Verhandeling IV), Brussels, 1945.

10. See Dhanens, *Het retabel,* op. cit. (1965), p. 95, and ibid., (1969), p. 361.

11. Recorded by Marcus van Vaernewyck, *Den Spieghel der Nederlandscher Audtheyt*, Ghent, 1568, fol. CXIX, and by Christoffel van Huerne (published by Renders, op. cit., p. 38 and pls. 12–13). See also J. Duverger, op. cit. (1945), p. 18. Dhanens, *Het retabel*, op. cit. (1965), p. 113. English translation in W. H. J. Weale, *Hubert and John van Eyck, their Life and Work*, London and New York, 1908, pp. 6–7.

12. His account was first published by K. Voll, *Beilage der Allgemeine Zeitung*, nr CCXCIV, 7 September 1899. Dhanens, *Het retabel*, op. cit. (1965), p. 102.

13. L. Pastor, 'Die Reise des Kardinals Luigi d'Aragona durch Deutschland, die Niederlände, Frankreich, Oberitalien, 1517–1518, beschrieben von Antonio de Beatis', in *Erläuterungen und Ergänzungen zu Janssens Geschichte des Deutschen Volkes*, IV, part iv, Freiburg i.Br., 1905, pp. 117–18. Dhanens, *Het retabel*, op. cit. (1965), pp. 102–3.

14. See J. Duverger, 'De paramenten van de Joos Vydkapel van de Sint-Baafskerk te Gent', *Artes Textiles*, II, 1955, p. 46.

15. J. Duverger, 'Kopieën van het "Lam Gods"—retabel van Hubrecht en Jan van Eyck', *Bulletin Koninklijke Musea voor Schone Kunsten Brussel*, III, 1954, p. 55. The copy did not include the Altarpiece's predella, which had been destroyed before 1550.

16. L. De Heere, *Den Hof en Boomgaerd der Poësien*, Ghent, 1565, pp. 35–8. Dhanens, *Het retabel*, op. cit. (1965), pp. 104–5.

17. M. van Vaernewyck, *Den Spieghel der Nederlandscher Audtheyt*, Ghent, 1568, fol. CXVII[CXVIII]–CXIX, and *Van die Beroerlicke Tijden in die Nederlanden en voornamelijk in Ghendt, 1566–1568*, ed. F. Vanderhaeghen, Ghent, 1872–81, I, pp. 88 and 143–6. Dhanens, *Het retabel*, op. cit. (1965), pp. 110–15 and 108–10 respectively.

18. L. Guicciardini, *Descrittione di tutti i Paesi Bassi*, Antwerp, 1567, p. 97, whose information was partly taken over by Vasari in the second edition of his *Lives* (1568); Carel van Mander, *Het Schilder-Boeck*, Haarlem, 1604, fol. 199–203. These sources, and passages mentioning the Altarpiece in the writings of a number of sixteenth- and seventeenth-century poets and compilers, such as P. Opmeer, D. Lampsonius, A. Miraeus, M. De Vriendt and A. Sanderus have been discussed by L. Scheewe, *Hubert und Jan van Eyck. Ihre literarische Würdigung bis ins 18. Jahrhundert*, The Hague, 1933.

19. For Joos Vijd see P. de l'Espinoy, *Recherches des antiquitez et noblesse de Flandre*, Douai, 1632, pp. 574, 609, 629, 639, and 645; V. Fris, 'De onlusten te Gent in 1432–1435', *Bulletijn der Maatschappij van Geschied- en Oudheidkunde te Gent*, 1900, pp. 163–73; V. Fris, 'Josse Vyt, le donateur de l'Adoration de l'Agneau Mystique', in ibid., 1907, pp. 84–9; V. Fris, 'Notes pour servir à l'histoire du patriciat Gantois', in ibid., 1909, p. 290; P. de Maesschalck, 'Josse Vydt, le donateur de l'Agneau Mystique et quelques membres de sa famille', *Annalen van den Oudheidkundigen Kring van het Land van Waas*, 1919–20,

pp. 13-36; and G. Kestens, 'Joost de Vydt, Heer van Pamel', *Eigen Schoon en De Brabander*, X, 1928, pp. 203-4.

For Elisabeth Borluut, see the genealogy of the Borluuts given by Kervyn de Volkaersbeke is his *Histoire généalogique de quelques familles de Flandre*, Ghent, s.d. [1847] completed 1874. For both see also Dhanens, *Het retabel*, op. cit. (1965), pp. 27-32 and 85-6.

For Nikolaas Vijd see De Schoutheete de Tervarent, *Livre des feudataires des comtes de Flandre au Pays de Waes au XIVe, XVe, XVIe siècles* (Publications extraordinaires du Cercle Archéologique du Pays de Waes, IX), Sint-Niklaas-Waas, 1872; de Tervarent, 'Les anciennes magistratures du Pays de Waas et leurs titulaires. Recherches historico biographiques d'Emm. M. J. van der Vynckt', *Annalen van den Oudheidkundigen Kring van het Land van Waas*, 1867-9, pp. 76 and 133; G. van Herreweghen, 'De kapel te Ledeberg', *Eigen Schoon en De Brabander*, XLVI, 1963, p. 305; and J. van Rompaey, *Het grafelijk baljuwsambt in Vlaanderen tijdens de Boergondische periode* (Koninklijke Vlaamse Academie voor Wetenschappen, Letteren en Schone Kunsten van België, Klasse der Letteren, Verhandeling LXII), Brussels, 1967, pp. 425-6 (where, however, it is not realized that Nikolaas Vijd was the father of Joos, the donor of the Altarpiece; see E. Dhanens, 'Bijdrage betreffende het Lam-Godsretabel te Gent', *Festschrift für Wolfgang Krönig*, Aachener Kunstblätter, 41, 1971, pp. 100-101.

20. Ghent City Archives, MS. city accounts for 1436-7, fol. 61 v.; first published by V. Fris, 'Notes pour servir . . .', op. cit. (1909), p. 290.

21. This hypothesis was much discussed early in the present century (references in Dhanens, *Het retabel*, op. cit. [1965], p. 29). It gave rise to a theory that there had been a 'pre-Ghent Altar' (vorgentischen Altar, see E. Schenk, 'Selbstbildnisse von Hubert und Jan van Eyck?', *Zeitschrift für Kunst*, III, 1949, pp. 16-17). E. Panofsky, *Early Netherlandish Painting. Its Origin and Character*, Cambridge (Mass.), 1952, vol. I, p. 217, supposed that the Altarpiece was first commissioned by the Ghent city government and H. von Einem, 'Bemerkungen zur Sinneinheit des Genter Altares', *Miscellanea J. Duverger*, Ghent, 1968, vol I, pp. 33-5, that it was first intended for the high altar of St John's Church (later St Bavo's).

22. L. van Puyvelde, 'De Taal van Jan van Eyck', *Koninklijke Vlaamse Academie voor Taal en Letterkunde, Verslagen en Mededelingen*, 1955, pp. 213-23; A. Ampe and J. Goosens, 'Taal en herkomst van Jan van Eyck', *Wetenschappelijke Tijdingen*, 1970, pp. 81-91.

23. Ghent City Archives, MS. *Register van Staten*, 1425-6, fol. 63; first published by V. van der Haeghen, op. cit., p. 31. Dhanens, *Het retabel*, op. cit. (1965), pp. 87-8.

24. Ghent City Archives, MS. city accounts for 1424-5, fol. 188, and for 1425-6, fol. 288 v.; first published by J. de Smet, 'L'Adoration de l'Agneau par les frères Van Eyck', *Inventaire archéologique de Gand*, Ghent, 1902, nos. 241-50. Dhanens, *Het retabel*, op. cit. (1965), pp. 86-7.

25. Ghent City Archives, MS. city accounts for 1426-7, fol. 319 v.; first published by C. Carton, *Les trois frères van Eyck*, Bruges, 1848, p. 37. Dhanens, *Het retabel*, op. cit. (1965), p. 88.

26. This must have been Henry Beaufort, son of John of Gaunt and Catherine Swynford, who was created cardinal by Martin V. He was Bishop of Winchester from 1405 to 1447.

27. Ghent City Archives, MS. *Fonds Sint-Pietersabdij*, Series 1, no. 866, fol. 18; first published by J. Duverger, *Het grafschrift van Hubrecht Van Eyck . . .* op. cit. (1945), p. 67, note. Dhanens, *Het retabel*, op. cit. (1965), p. 89.

28. Ghent City Archives, MS. *Jaerregistre*, 1438-9, fol. 129, and 1439-40, fol. 109 v.; first published by V. van der Haeghen, 'Autour des Van Eyck, Cartulaire', op. cit., pp. 64-6. Dhanens, *Het retabel*, op. cit. (1965), pp. 93-5.

29. For detailed comment on the original setting and later changes, see E. Dhanens, 'De wijze waarop het Lam-Godsaltar was opgesteld', *Gentse Bijdragen tot de Kunstgeschiedenis en de Oudheidkunde*, xxii, 1969-72, pp. 109-50.

30. See *Later History and Influence*, under 1950-51, p. 137 above.

31. In 1951 the wing panels were set in bronze frames forming single shutters like those of a triptych, to enable the Altar to be shown to visitors more easily.

32. F. de Potter, *Second Cartulaire de Gand*, Ghent, n.d., p. 378.

33. *Kronyk van Vlaenderen* (Maetschappij der Vlaemsche Bibliophilen), Ghent, 1840, pp. 222-5. Another transcription in J. de Baets O.P., 'De gewijde teksten van het "Lam Gods" kritisch onderzocht', *Koninklijke Vlaamse Academie voor Taal en Letterkunde, Verslagen en Mededelingen*, 1961, pp. 612-14. Dhanens, *Het retabel*, op. cit. (1965), pp. 96-9.

34. St Bavo's Ghent, no. 745, MS. *De ghelase veinsteren*, fol. 12 v. Dhanens, *Het retabel*, op. cit. (1965), p. 117.

35. R. R. Post, *Geert Grootes tractaat 'Contra turrim Traiectensem' teruggevonden*, The Hague, 1967.

36. See E. R. Curtius, *European Literature and the Latin Middle Ages*, New York, 1953, pp. 192-201.

37. As a literary source for the Just Judges panel, Professor J. Steppe proposes the moralizing treatise of Jacques de Cessoles, *Liber de Moribus hominum et officiis nobilium sive super ludum scacchorum*, early fourteenth century. Professor Steppe intends to publish his findings on this question.

38. See J. P. Migne, *Patrologia Latina*, vols. CLXVII-CLXX, Paris, 1854, especially CLXX, 11-14 and 27.

39. E. Beitz, *Rupert von Deutz, seine Werke und die Bildende Kunst*, Cologne, 1930. For recent bibliographies concerning Rupert of Deutz see H. Silvestre, 'La tradition manuscrite des oeuvres de Rupert de Deutz. A propos d'une étude récente de Rhaban Haacke', *Scriptorium*, XVI, 1962, pp. 336-48; and *Lexikon für Theologie und Kirche*, IX, 1964, pp. 104-6.

40. Migne, op. cit., CLXIX, 1478-9.

41. ibid., CLXVIII, 1311.

42. *Sacerdos magnus . . . pontifex magnus*, Migne, CLXVII, 324; *rex . . . et sacerdos*, id., CLXVII, 1535; *rex est et pontifex magnus*, id. CLXVIII, 938.

43. Migne, op. cit., CLXIX, 1165.

44. Migne, op. cit., CLXIX, 1228 and 1292.

45. ibid., CLXIX, 1222.

46. ibid., CLXX, 218-40.

47. ibid., CLXIX, 1217.

48. ibid., CLXIX, 1233, 1240-44, etc.

49. ibid., CLXIX, 1244.

50. ibid., CLXIX, 1258 and 1260.

51. ibid., CLXVIII, 700-814 and 441-526 respectively.

52. ibid., CLXVII, 1425.

53. Migne, op. cit., CLXIX, 1277-9.

54. Migne, op. cit., CLXVIII, 838-962.

55. ibid., CLXIX, 1280.

56. ibid., CLXVIII, 236.

57. ibid., CLXIX, 1441 and 1473.

58. ibid., CLXX, 166 and 607.

59. ibid., CLXVIII, 1389.

60. Migne, op. cit., CLXVIII, 253-5, 797; CLXIX, 36-9, 520-22, 1206; and CLXX, 274-6.

61. ibid., CLXIX, 1500 and 1501.

62. *Dye declaratie vander missen na dye meyninghe vanden heylighen Apostolen ende die discipelen ons Heeren, ende van die oude doctoren der heylighen kercken te weten Dionisius, Origenes, Johannes Chrysostomus, Augustinus, Gregorius, Gelasius, Rupertus ende meer andere* [etc.], 2nd edition, Antwerp 1551. First published Antwerp, 1529.

63. See P. Coremans and others, *L'Agneau mystique au laboratoire. Examen et traitement* (Les Primitifs Flamands, III, Contributions à l'étude des Primitifs Flamands, II), Antwerp 1953, pp. 119-20 and pl. LXII.

Bibliography

A survey of principal publications concerning the Ghent Altarpiece which have appeared in the present century is given here. For early literature the following may be referred to: L. SCHEEWE, *Hubert und Jan van Eyck. Ihre literarische Würdigung bis ins 18.Jahrhundert*, The Hague, 1933. Bibliographies covering the literature of the nineteenth century and the first years of the twentieth are given by V. FRIS, 'Bibliographie des Van Eyck', *Bulletin de la Société d'Histoire et d'Archéologie de Gand*, XIV (1906), pp. 313-33, and W. H. J. WEALE, *Hubert and John van Eyck, their Life and Work*, London and New York, 1908. More recent literature is listed in H. VAN HALL, *Repertorium voor de geschiedenis der Nederlandsche schilder-en graveerkunst*, The Hague, 1936-62, and in *The Bibliography of the Rijksbureau voor Kunsthistorische Documentatie* (Netherlands Institute of Art History), The Hague, 1943-. A bibliography by F. O. BÜTTNER giving literature on the Van Eycks which has appeared during the last twenty years is in preparation.

Documents and texts from literary sources concerning the Ghent Altarpiece, many of which are discussed or mentioned in the present work, will be found in the author's short study *Het retabel van het Lam Gods in de Sint-Baafskathedraal te Gent* (Inventaris van het Kunstpatrimonium van Oost-Vlaanderen, VI), Ghent, 1965. For the reader's convenience this study is referred to in footnotes concerning such documents and texts.

AERTS, L., *De Aanbidding van het Lam Gods*. Diest, 1943.

BAETS, J. de, O. P., 'De gewijde teksten van het "Lam Gods" kritisch onderzocht', *Koninklijke Vlaamse Academie voor Taal en Letterkunde, Verslagen en Mededelingen*, 1961, pp. 531-614.

BALDASS, L., 'The Ghent Altarpiece of Hubert and Jan van Eyck', *Art Quarterly*, XIII, 1950, pp. 140-55 and 182-95.

—, *Jan van Eyck*, London, 1952.

BANDMANN, G., 'Ein Fassadenprogramm des 12. Jahrhunderts und seine Stellung in der christlichen Ikonographie', *Das Münster*, V, 1952, pp. 1-21.

BAUCH, K., 'Bildnisse des Jan van Eyck', *Studien zur Kunstgeschichte*, Berlin, 1967.

BEENKEN, H., 'Streit um Hubert van Eyck', *Kritische Berichte zur kunstgeschichtliche Literatur*, III-IV, 1933, pp. 225-34.

—, *Hubert und Jan van Eyck*, Munich, 1941.

BOETHIUS, G., *Bröderna Van Eyck*, Stockholm, 1946.

BONTINCK, E., 'Natuurwetenschappelijk onderzoek van de opschriften en de lijst van het Lam Gods-retabel', in J. Duverger, *Het grafschrift van Hubrecht van Eyck en het quatrain van het Gentsche Lam Gods-retabel* (Koninklijke Vlaamse Academie voor Wetenschappen, Letteren en Schone Kunsten van België, Klasse Schone Kunsten, Verhandeling IV), Brussels, 1945, pp. 74-82.

BRAND PHILIP, L., 'Raum und Zeit in der Verkündigung des Genter Altares'. *Wallraf-Richartz Jahrbuch*, XXIX, 1967, pp. 62-104.

—, *The Ghent Altarpiece and the Art of Jan van Eyck*, Princeton and Oxford, 1972.

CONWAY, M., *The Van Eycks and their Followers*, London, 1921.

COREMANS, P. and A. JANSSENS DE BISTHOVEN, *Van Eyck. L'Adoration de l'Agneau Mystique*, Amsterdam and Antwerp, 1948.

COREMANS, P. and others, *L'Agneau mystique au laboratoire. Examen et traitement* (Les Primitifs Flamands, III, Contributions à l'étude des Primitifs Flamands, II), Antwerp, 1953.

DHANENS, E., *Het retabel van het Lam Gods in de Sint-Baafskathedraal te Gent* (Inventaris van het Kunstpatrimonium van Oost-Vlaanderen, VI), Ghent, 1965.

—, 'De meetkundige harmonie in de kompositie van het Lam Gods-retabel te Gent', *Gentse Bijdragen tot de Kunstgeschiedenis en de Oudheidkunde*, XX, 1967, pp. 23-54.

—, 'Bijdrage betreffende het Lam Godsretabel te Gent', *Festschrift für Wolfgang Krönig*, Aachener Kunstblatter, 41, 1971, pp. 100-108.

—, 'De wijze waarop het Lam-Godsaltar was opgesteld', *Gentse Bijdragen tot de Kunstgeschiedenis en de Oudheidkunde*, xxii, 1969-72, pp. 109-50.

DUVERGER, J., *Het grafschrift van Hubrecht van Eyck en het quatrain van het Gentsche Lam Gods-retabel* [etc.] (Koninklijke Vlaamse Academie voor Wetenschappen, Letteren en Schone Kunsten van België, Klasse Schone Kunsten, Verhandeling IV), Brussels, 1945.

—, 'Kopieën van het "Lam Gods"-retabel van Hubrecht en Jan van Eyck', *Bulletin Koninklijke Musea voor Schone Kunsten, Brussel*, III, 1954, nr 2, pp. 51-68.

—, 'De navorsing betreffende de Van Eyck's', *Het Oude Land van Loon*, IX, 1954, pp. 192-210.

DVORAK, M., 'Das Rätsel der Kunst der Brüder Van Eyck', *Jahrbuch der Kunsthistorischen Sammlungen des Allerhöchsten Kaiserhauses*, XXIV, Vienna, 1904, pp. 162-317. (Published in book form Munich, 1925.)

FAIDER, P., 'Pictor Hubertus. A propos d'un ouvrage récent d'E. Renders', *Revue belge de philologie et d'histoire*, 1933, pp. 1273-91.

FIERENS-GEVAERT, H., *Le polyptyque de l'Agneau des frères van Eyck et le retable du St Sacrement de Dieric Bouts à Bruxelles. Notice sur les deux chefs-d'oeuvre et leurs auteurs.* Turnhout, 1920.

FRIEDLANDER, M. J., *Der Genter Altar der Brüder van Eyck*, Munich, 1920-21.

—, *Die altniederländische Malerei*, I, *Die Van Eyck - Petrus Christus*, Berlin, 1924.

—, *Early Netherlandish Painting*, I, *The Van Eycks - Petrus Christus*, Leiden and Brussels, 1967.

FRIS, V., *De altaartafel 'De Aanbidding van het Lam Gods' der gebroeders Van Eyck*, Antwerp, 1921.

GESSLER, J., 'Het probleem Van Eyck en de "Aanbidding van het Lam Gods"', *Limburg*, XXXIII, 1954, pp. 81–93, 107–18 and 121–9.

GHEYN, G. van den. 'L'Interprétation du Retable de Saint-Bavon à Gand', *Handelingen der Maatschappij van Geschiedenis Oudheidkunde te Gent*, XVI, 1920, pp. 1–30.

—, 'Les tribulations de l'Agneau Mystique', *Revue belge d'archéologie et d'histoire de l'art*, XV, 1945, pp. 25–46.

GÜNTHER, R., *Die Bilder des Genter und des Isenheimer Altars. Ihre Geschichte und Deutung*, I, *Der Genter Altar und die Aller-heiligenliturgie*, Leipzig, 1923.

HAEGHEN, V. van der. 'Autour des van Eyck, Cartulaire', *Handelingen der Maatschappij van Geschied- en Oudheidkunde te Gent*, XV, 1914, pp. 1–68.

HULIN DE LOO, G., 'La fameuse inscription du rétable de l'Agneau', *Revue archéologique*, III, 1934, pp. 62–87.

—, 'Le sujet du rétable des frères van Eyck à Gand. La glorification du Sauveur', *Annuaire des Musées royaux des Beaux-Arts de Belgique*, Brussels, 1940–41, pp. 1–16.

JANSON, C., 'De Pietro Lorenzetti aux van Eyck', *Revue des Arts*, II, 1952, pp. 224–6.

JOSEPHSON, R., 'Die Froschperspektive des Genter Altars', *Monatshefte für Kunstwissenschaft*, VIII, 1915, pp. 198–201.

KEYSER, P. de, 'De kunsthistoriografie van Gent sedert 1914', *Handelingen der Maatschappij van Geschied- en Oudheidkunde te Gent*, I, 1944, pp. 7–37.

LEMAIRE, R., *Wat verbeeldt het Lam Gods?* (Koninklijke Vlaamse Academie voor Wetenschappen, Letteren en Schone Kunsten van België, Klasse Schone Kunsten, Mededelingen, VII, I), Brussels, 1945.

LÖHNEYSEN, H. W. von, *Die ältere Niederländische Malerei. Künstler und Kritik*, Eisenach and Kassel, 1956.

MARIEN-DUGARDIN, A., 'Les draps d'honneur du retable de l'Agneau Mystique', *Bulletin de la Société Royale d'Archéologie de Bruxelles*, 1947–8, pp. 18–21.

MELLER, P., 'Zur Ikonographie und Entstehung des Genter Altars'. *Kunstgeschichtliche Gesellschaft zu Berlin, Sitzungsberichte*, 1966–7, pp. 4–10.

PANOFSKY, E., *Early Netherlandish Painting. Its Origin and Character*, Cambridge (Mass.), 1953, 2 vols.

PEETERS, F., 'Les Noces Eucharistiques de l'Agneau', *Revue belge d'archéologie et d'histoire de l'art*, II, 1932, pp. 144–53.

PETERS, H., 'Die Anbetung des Lammes, ein Beitrag zum Problem des Genter Altars', *Das Münster*, III, 1950, pp. 65–77.

POST, P., 'Pictor Hubertus Deyck major quo nemo repertus. Eine Untersuchung zur Genter Altar-Frage auf Grund des Tatsächlichen', *Zeitschrift für Kunstgeschichte*, XV, 1952, pp. 46-68.

PUYVELDE, L. van, *Het Lam Gods*, Rotterdam, 1946.

—, *L'Agneau Mystique*, Paris and Brussels, 1946.

—, *The Holy Lamb*, London and New York, 1948.

RENDERS, E., *Hubert van Eyck, personnage de légende*, Paris and Brussels, 1933.

ROGGEN, D., 'Van Eyck en François Villon', *Gentse Bijdragen tot de Kunstgeschiedenis*, XIII, 1951 (published in 1952), pp. 259-67.

SCHEEWE, L. *Hubert und Jan van Eyck. Ihre literarische Würdigung bis ins 18. Jahrhundert*, The Hague, 1933.

—, 'Die Van Eyck-literatur der beiden letzten Jahre', *Zeitschrift für Kunstgeschichte*, III, 1934, pp. 139-43; IV, 1935, pp. 256-9; VI, 1937, pp. 407-10; and VII, 1938, p. 107.

SCHMARSOW, A., *Hubert und Jan van Eyck*. Leipzig, 1924.

SULZBERGER, S., 'Les premières reproductions graphiques du retable de l'Agneau Mystique', *Gazette des Beaux-Arts*, 1958, pp. 313-18.

TOLNAY, C. de, *Le Retable de l'Agneau Mystique des frères Van Eyck*, Brussels, 1938.

WEALE, W. H. J., *Hubert and John van Eyck, their Life and Work*. London and New York, 1908.

WINKLER, F., *Der Genter Altar von Hubert und Jan van Eyck*, Leipzig, 1921.

—, 'Der Streit um Hubert van Eyck', *Zeitschrift für Kunstgeschichte*, III, 1934, pp. 283-90.

ZILOTY, A., *La découverte de Jean van Eyck et l'évolution du procédé de la peinture à l'huile du Moyen Age à nos jours*, Paris, 1947.

List of Illustrations

(All photographs by A.C.L. unless credited otherwise.)

Colour plate and title page: *The Adoration of the Lamb*, central panel of the Ghent Altarpiece. By Hubert and Jan van Eyck, completed 1432. Oil on panel, 134.3 x 237.5 cm. Ghent, St Bavo's Cathedral.

1. The Ghent Altarpiece, open. By Hubert and Jan van Eyck, completed 1432. Oil on panels. Lower register panels: *The Just Judges* (copy by J. van der Veken 1939–40 after lost original), *The Knights of Christ* (146.2 x 51.4 cm.), *The Adoration of the Lamb* (134.3 x 237.5 cm.), *The Holy Hermits* (146.4 x 51.2 cm.), *The Holy Pilgrims* (146.5 x 52.8 cm.). Upper register panels: *Adam* with *Cain and Abel* above (204.3 x 33.2 cm.), *The Singers* (161.7 x 69.3 cm.), *The Virgin Enthroned* (166·8 x 72·3 cm.), *Christ Enthroned* (210·5 x 80 cm.), *St John the Baptist Enthroned* (162.2 x 72 cm.), *The Musicians* (161.1 x 69.3 cm.), *Eve* with *Cain and Abel* above (204.3 x 32.3 cm.). Ghent, St Bavo's Cathedral. Photograph taken at the exhibition in Brussels, 1951.

2. The Ghent Altarpiece, closed. By Hubert and Jan van Eyck, completed 1432. Oil on panels. Lower register panels: *Joos Vijd* (145.7 x 51 cm.), *St John the Baptist* (146 x 51.8 cm.), *St John the Evangelist* (146.4 x 52.6 cm.), *Elisabeth Borluut* (145.8 x 50.7 cm.). Upper register panels: *The Archangel Gabriel* with *The Prophet Zechariah* above (162.5 x 69.1 cm.); interior with the *Erythraean Sibyl* above (204.8 x 33 cm.); interior with the *Cumaean Sibyl* above (204.5 x 32.3 cm.), *The Virgin Annunciate* with the *Prophet Micah* above (161.5 x 69.6 cm.). Ghent, St Bavo's Cathedral. Montage made by A.C.L.

3. Detail of the *Joos Vijd* panel.

4. The *St John the Baptist* panel.

5. Detail of the *St John the Baptist Enthroned* panel.

6A. Section of the Vijd Chapel, St Bavo's Cathedral, Ghent; 6B, plan of the cathedral showing location of the Vijd Chapel. Drawn by Professor Dr F. de Smidt.

7A, B. The *Joos Vijd* and *Elisabeth Borluut* panels.

8. Detail of *The Adoration of the Lamb* panel.

9. The Dedicatory Inscription.

10A, B. The *Prophet Micah* panel, and detail.

11. Detail of the *Adam* panel.

12. Detail of the *Joos Vijd* panel.

13. Detail of the *Elisabeth Borluut* panel.

14. *Portrait of a Man with a Turban*. By Jan van Eyck, 1433. London, National Gallery.

15. The *St John the Evangelist* panel.

148

16. The *Annunciation* panels.

17. Detail of one of the *Annunciation* panels.

18. Detail of *The Adoration of the Lamb* panel.

19. Detail of *The Adoration of the Lamb* panel.

20. Prophets and Patriarchs, detail of *The Adoration of the Lamb* panel.

21. Virgil, detail of 20.

22. Apostles and Clergy, detail of *The Adoration of the Lamb* panel.

23. The Popes, detail of 22.

24. The Confessors, detail of *The Adoration of the Lamb* panel.

25. The Female Saints, detail of *The Adoration of the Lamb* panel.

26. Lilies, detail of *The Adoration of the Lamb* panel.

27. The Tower of Utrecht Cathedral, detail of *The Adoration of the Lamb* panel.

28. The Tower of St Nicholas Church, Ghent, detail of *The Adoration of the Lamb* panel.

29. Meadow flowers, detail of *The Adoration of the Lamb* panel.

30. Landscape, detail of *The Holy Hermits* panel.

31. Landscape, detail of *The Holy Pilgrims* panel.

32. Detail of *The Holy Hermits* panel.

33. Detail of *The Holy Pilgrims* panel.

34. Detail of *The Knights of Christ* panel.

35. *The Just Judges* panel, detail of original panel, now lost.

36. Detail of 34.

37. *Christ Enthroned* panel.

38. Detail of 37.

39. Detail of 37.

40. Detail of *The Virgin Enthroned* panel.

41. The *St John the Baptist Enthroned* panel.

42. Detail of 41.

43. Detail of *The Singers* panel.

44. Detail of *The Musicians* panel.

45. Detail of *The Musicians* panel.

46. Detail of the *Eve* panel.

47. Detail of the *Christ Enthroned* panel.

48. Detail of *The Singers* panel.

49. Detail of *The Singers* panel.

50. The *Cain Slaying Abel* panel.

51. Detail of *The Virgin Annunciate* panel.

52. Detail of *The Adoration of the Lamb* panel.

53. Detail of 52.

54. Detail of the *Christ Enthroned* panel.

55. Detail of *The Adoration of the Lamb* panel.

56. *Paradise*. By Jacobello del Fiore, 1432 or 1438. Venice, Accademia. (Photo: Alinari.)

57. The *Adam* and *Eve* panels.

58. *Adam and Eve*. By Masaccio, *c.* 1426-8. Florence, Sta Maria del Carmine. (Photo:Alinari.)

59. *God the Father*. By Donatello, *c.* 1417. Florence, Orsanmichele. (Photo: Alinari.)

60. The *Prophet Zechariah* panel.

61. Detail of 65, infra-red photograph showing the over-painted arches and tracery (here strengthened with black ink; drawn by Miss Sheila Gibson).

62A. Study of the Altar's geometric scheme based on archaeological evidence, with plan of the eastern arcade of the chapel.

62B. Tentative reconstruction of the closed Altarpiece's conception.

63A, B. *The Singers* panel and *The Musicians* panel.

64. *The Madonna of Chancellor Rolin*. By Jan van Eyck. Paris, Musée du Louvre.

65. *The Archangel Gabriel* panel.

66. *Wedding Portrait of Giovanni Arnolfini*. By Jan van Eyck, 1434. London, National Gallery.

67. Detail of *The Adoration of the Lamb* panel.

68. Detail of one of the *Annunciation* panels.

69. Detail of *The Virgin Enthroned* panel.

70. Detail of the *Adam* panel.

71. Detail of *The Adoration of the Lamb* panel.

72. Detail of one of the *Annunciation* panels.

73. *The Virgin Enthroned* panel.

74. *The Lucca Madonna*. By Jan van Eyck. Frankfurt, Städelsches Kunstinstitut. (Photo: Museum.)

75. *The Fountain of Life*. Anonymous Flemish artist. Madrid, The Prado. (Photo: Anderson.)

76. *The Vijd Chapel*. P. F. De Noter, 1829. Amsterdam, Rijksmuseum. (Photo: Museum.)

77. *The Ghent Altarpiece in situ*.

Index

Bold numbers refer to illustration numbers